50 GEM
Suffolk

KATE J. COLE

AMBERLEY

This book is dedicated to my greatly missed and much-loved Dad,
William 'John' Cole (1931–2016)

First published 2018

Amberley Publishing
The Hill, Stroud
Gloucestershire, GL5 4EP

www.amberley-books.com

Copyright © Kate J. Cole, 2018

Map contains Ordnance Survey data © Crown copyright and database right [2018]

The right of Kate J. Cole to be identified as the Author
of this work has been asserted in accordance with the
Copyrights, Designs and Patents Act 1988.

British Library Cataloguing in Publication Data.
A catalogue record for this book is available from the British Library.

ISBN 978 1 4456 6542 9 (paperback)
ISBN 978 1 4456 6543 6 (ebook)

Origination by Amberley Publishing.

Printed in Great Britain.

Contents

A12 Lowestoft

A134

River Yare
Loddon
A143
A146 A143

Beccles

Southwold
50
49
47
46 45
48 Halesworth
Bungay A12 Saxmundham
44 43 Aldeburgh
42
Orford Ness
38
37 39

Rendlesham
36
35

Felixstowe
31
30

A143 Harleston

River Waveney

River Alde

River Deben

River Deben Woodbridge
34
41 33 32
29 28 Harwich
A11
Attleborough

A1066

Diss

Eye

Framlingham 40
Debenham
Wickham Market
A12
27 26
Ipswich
24 23
25 22
A120

Watton

The Brecks

A143

Ixworth

A140

Claydon
A14

A12
20
21

Mannington
A120

A11
A1065

Thetford

A134

A14

Stowmarket

Hadleigh
17 19
16
15 18
Dedham Vale

A11

8

9

SUFFOLK

Lavenham
14

River Stour

Mundford
A134

Brandon

Mildenhall
3
A11
A134

A11

6 7

Bury St Edmunds
5

13
Sudbury
12

11

A131
Halstead

Little Ouse River

Stoke Ferry
A10

A134

4

2

10

Haverhill

Saffron Walden

A122

Littleport

Soham
A142

Newmarket
1

A14

A11

A11

M11

River Blackwater

Introduction

When Amberley Publishing first asked me to write and provide photographs for a book documenting fifty gems of Suffolk, I must admit to taking a sharp intake of breath. What to choose from this stunning county? Although I live in Essex, I spend a great deal of my week driving, travelling and exploring the Suffolk countryside. Therefore, I'm well equipped to write about and photograph one of England's most beautiful counties.

But only fifty gems? Suffolk has countless architectural highlights and attractions. So many so that the latest edition of Pevsner's classic *The buildings of England* series has to run to two substantial volumes for the county. It also has seven local government districts; a population of 0.75 million people (in 2011); over 400 towns and villages, including what were once some of the wealthiest towns in medieval England; the ruins of several vast and powerful medieval abbeys that were dissolved by Henry VIII in the 1500s; a number of medieval castles, including some of Norman origin; an impressive, world-renowned Anglo-Saxon site; several historic buildings managed by either the National Trust or English Heritage; many nature reserves run by Suffolk Wildlife Trust, the National Trust or the Royal Society for the Protection of Birds (RSPB); ancient and modern long- or short-distance footpaths; over 400 churches – several of which are England's great medieval wool churches; a stunning coastline that sweeps through large seaside towns and tiny fishing villages; Suffolk Coast and Heaths, a region officially classed as an Area of Outstanding Natural Beauty, which contains coastline, ancient woodland, the estuaries of five major rivers, salt marshes and mudflats, grasslands, heathlands, shingle and sandy beaches, and a fast-eroding shoreline; several ancient woodlands and forests along with numerous Sites of Special Scientific Interest (SSSI), Special Areas of Conservation (SAC), Special Protection Areas (SPA) and Ramsar sites; and an extraordinary artistic culture – from the modern-day pop star Framlingham resident Ed Sheeran to old masters such as John Constable and Thomas Gainsborough, along with literary talent including Arthur Ransome, P. D. James and George Orwell.

My brief from Amberley Publishing was to select my own personal fifty gems – choices that meant something personal to me – and then write about and photograph them. So here they are. Some you might agree with, others you

might not. For ease of reading and for carrying the book out and about with you, I have split my book into four geographical sections. But these sections are merely my own inventions and do not form nor follow any real boundaries.

Kate J. Cole
thenarrator@essexvoicespast.com
www.essexvoicespast.com

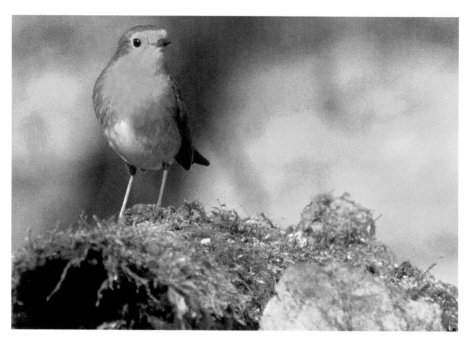

A friendly robin at Lackford Lakes Nature Reserve.

North-West

1 National Horseracing Museum, Newmarket

As someone who was born in Epsom and spent my formative years there, a town that is esteemed for horse racing, it seems appropriate for me to start my book with Newmarket and the National Horseracing Museum. To call this a 'museum' does not do this incredible centre proper justice. Its formal title is the National Heritage Centre for Horseracing & Sporting Art. It is part art gallery, part museum, part former royal palace and part working stables for the retraining of former racehorses.

Horseracing is in the lifeblood of this market town. From a population of over 20,000 people, one in three local jobs are in connection to horses and horse racing. The stats for the town's racing heritage are extraordinary: two racetracks, 3,500 racehorses, over sixty horse-breeding studs and fifty horse-training stables.

Newmarket and horse racing first received royal approval during the reign of James I, who built a fine palace in the High Street in 1615. The king often stayed in his Newmarket palace. He spent his time in the town cockfighting, hunting and watching impromptu horseraces on Newmarket's heath. Thus, horse racing in Newmarket is thought to have begun by James I.

His son, Charles I, also visited Newmarket to take part in the town's booming leisure and sporting pursuits. He made his final visit to his Newmarket palace on the way to his execution at Banqueting House in London during January 1649.

During the interregnum after the death of Charles I, the royal palace was little used and fell into disrepair. After the Restoration of Monarchy in 1660, Charles II decided that his grandfather's original palace was not suitable for his needs. Instead, in 1668 he bought a house further to the east of the old palace and built a new grand and extensive palace complex.

Over the centuries Charles II's palace has been demolished; however, a small fragment of his former royal home, the King's Lodgings (the royal chambers where he once slept), has survived and is now a portion of the National Heritage Centre for Horseracing & Sporting Art. Today, after extensive renovation, the palace houses an impressive art gallery with an important collection of paintings from all forms of sport, not just horse racing.

Across the road from the Heritage Centre a complex of stables and the Trainer's House have been converted into galleries, displaying exhibits and memorabilia relating to horse racing. Here you can experience for yourself the thrills of horse racing by riding a life-sized pivotal horserace simulator. If that's not enough, then the Heritage Centre's crowning glory (and its very own unique gem) is a collection of stables known as the Rothschild Yard. In the yard you can meet former racehorses who are being retrained for a new life by the equine charity known as Retraining of Racehorses (RoR).

Twice each day, RoR staff exercise and train individual horses within the centre's own purpose-built arena (named after the horserace commentator, the late Peter O'Sullevan). These retraining sessions are open to the public to watch. The commitment, passion and knowledge of these trainers for their equine charges is remarkable.

The entire Heritage Centre is outstanding, not just because of its contents, but also because of the artwork, exhibitions and its work with former horse races. The very fabric of the buildings is also of great interest. Within the palace

Sculpture of the British thoroughbred racehorse Frankel, dubbed racing's superstar. In the middle of the image is Charles II's palace. To the left is the King's Yard Galleries, part of the National Horseracing Museum. To the right is the Trainer's House, also part of the museum. The 5-acre plot was extensively renovated and restored at a total cost of £15 million. The new complex was opened by the Queen in November 2016.

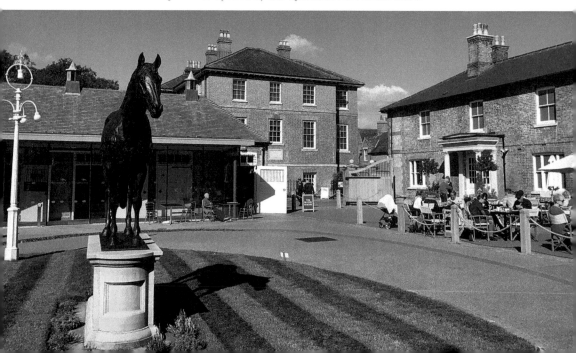

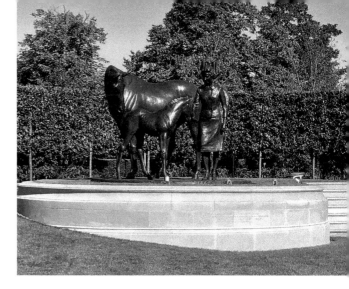

Queen Elizabeth's ninetieth birthday present from Sheik Mohammed Bin Rashid Al Maktoum, the ruler of Dubai, located at Birdcage Walk. The sculpture portrays the Queen with a mare and foal during her Silver Jubilee year – 1977.

is a window that is the earliest-known surviving example within England of a counterbalanced sliding sash window – a significant remnant of English architectural history.

The Heritage Centre is certainly remarkable and is well worth the entrance fee. The volunteers and staff are exceptionally knowledgeable about horses and horse racing and are willing to share their knowledge.

Details

To visit the museum, park in any of the numerous town centre car parks. Newmarket's ninetieth birthday statue of Queen Elizabeth is located outside the town centre, heading north on the A1304 at Birdcage Walk. Park on the roadside.

2 Moulton Packhorse Bridge

Claiming to be the oldest road in Britain, the ancient Icknield Way passes through the pretty village of Moulton on its 110-mile journey from Norfolk to Dorset. This ancient pathway is not the only route that once brought visitors through Moulton. In late medieval times, merchants with their trains of packhorses loaded with goods journeyed to and from Bury St Edmunds to Cambridge. When they arrived at Moulton they had to cross the River Kennett so, to cope with the river blocking their way, a four-arched bridge was built over the river. The material used was flint and stone rubble, with a brick facing to the arches.

The packhorses were driven in groups of up to fifty horses all walking in single file, attached to each other. The merchants' goods were carried in wicker baskets with large bundles of cloth hung over the animals. Several men walked alongside the packhorses, their numbers dependent upon the number of horses in the convoy and the value of the cargo.

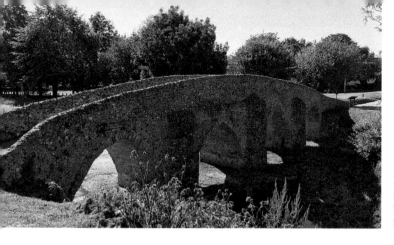

Moulton's late medieval packhorse bridge with its four brick-lined arches.

The bridge was evidently still in use in the eighteenth century as repairs were made to it at this time.

The packhorse bridge, village church and another bridge in the village were maintained by a charity set up prior to the Reformation in the 1530s. The Town Estate charity (also known as The Church and Bridges Estate) had at its disposal rents received from an estate of 4 acres of land at Freckenham and 13 acres from Moulton.

The bridge lies next to a ford that was used for carts too wide for the packhorse bridge. In recent times the ford has been lined with a concrete platform to allow cars to cross the river.

Details

The village is just over 3 miles from Newmarket. Once in the village, the bridge is along the appropriately named Bridge Street, north of the parish church. English Heritage maintain the packhorse bridge and public access is free. There is very limited parking close to the bridge or more parking within the village itself. Check the depth of the ford before attempting to cross it – there is a depth marker within the ford. On the day I visited, the ford was dry. The river has certainly shrunk since its medieval heyday. However, after heavy rainfall, the River Kennett has been known to flood causing the ford to become impassable.

3 West Stow Anglo-Saxon Village

In the 1840s, while extracting gravel for ballasting barges, workmen accidently discovered an Anglo-Saxon cemetery in heathland at West Stow. Approximately 100 skeletons were discovered, with their heads to the south-west and feet to the north-east. Discovered with the bodies were items such as urns, beads, brooches, spear blades, shield bosses, a sword and a stone coffin. No official excavation of nearby land took place at this time and so the artefacts discovered were kept privately by antiquarians.

Later, in the latter half of the nineteenth century, an amateur archaeologist found several Romano-British pottery kilns. Two further kilns from the same period were also discovered in the first half of the twentieth century by Basil Brown, the man who notably excavated Sutton Hoo's Anglo-Saxon burial ship.

Despite these early finds hinting at what else might be discovered, formal archaeological investigations did not take place until the middle of the twentieth-century. From the mid-1950s to the early 1970s, the Ministry of Public Building and Works excavated the land. They found that the land was inhabited by numerous peoples throughout thousands of years of history: from the Mesolithic period to Neolithic, Bronze Age, Iron Age and into the Romano-British era.

Archaeologists also found that the site had been extensively used during the Anglo-Saxon era from the mid-fifth century until the seventh century. It is thought that the settlement consisted of over seventy sunken-featured buildings, halls and animal pens.

In the 1970s an experimental archaeology project was set up to reconstruct the Anglo-Saxon village. Three reconstructed houses were built initially, but this ongoing project has now produced eight buildings. The reconstructed buildings are known as the craft building, farmer's house, hall building, living house, oldest house, sunken house, weaving house and workshop.

As archaeological techniques have developed and our knowledge of the Anglo-Saxon period have increased, then so too has the reconstruction of some of the buildings. In 2005, a fire caused the loss of the building known as the farmer's house. Rebuilding the house after the fire gave the museum the opportunity to try different building techniques. A new form of oak walling was utilised and a different technique was employed for the thatching on the roof.

The site also boasts a 125-acre country park with trails, heathland and woodland walks. There is also an interactive walk enticingly named Beowulf and Grendel Trail, which has sleeping dragons and wooden sculptures inspired by the site's Anglo-Saxon heritage.

The living museum stages living history days and exhibitions throughout the year. There are also extremely popular Ring Quest events celebrating Middle

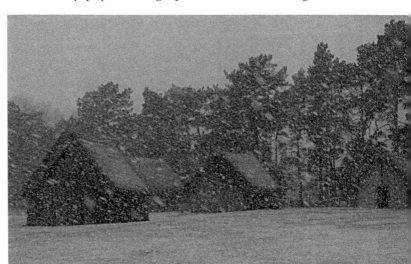

West Stow's reconstructed Anglo-Saxon village. A wintery snow blizzard in 2018. We can only imagine just how harsh life was in the Anglo-Saxon period.

Earth and the 'Lord of the Rings' in tribute to J. R. R. Tolkien, who was professor of Anglo-Saxon (Old English) at the University of Oxford.

Details
West Stow Anglo-Saxon Village and Country Park is located on Icklingham Road, to the west of West Stow village. There is a large pay and display car park, which is charged separately to the admission of the museum.

4 Lackford Lakes

Formerly sand and gravel workings set in the valley of the River Lark, this sequence of eleven flooded pits (now scenic lakes) is a Site of Special Scientific Interest (SSSI). Each lake has an abundant collection of birds, insects and small mammals who visit throughout the year. Kingfishers, swallows, willow warblers, whitethroats, siskins, redpoll, lapwings, cormorants, snipes, herons and nightingales are just a few birds that can be spotted. Each season brings a different set of birds; eighty-five different species were recorded in just the first month of 2018.

Lakeford Lakes has nine hides that are dotted throughout the reserve. Always calm and tranquil, one can lose a good few hours inside these hides watching and photographing the birds with their activities on the lakes.

The reserve is also noted for the number of different species of dragonflies and damselflies that inhabit the reserve during the summer months. Approximately seventeen different species have been recorded over the lakes and streams on the reserve.

Managed by Suffolk Wildlife Trust, one of the great benefits of Lackford Lakes is that, due to its compact size, it is accessible to less-able-bodied visitors. It also has an excellent visitors' centre where talks and workshops are held throughout the year.

Details
Lackford Lakes is on the A1101 between Mildenhall (to the west) and Bury St Edmunds (to the east). The site is free to visit and there is a large free car park.

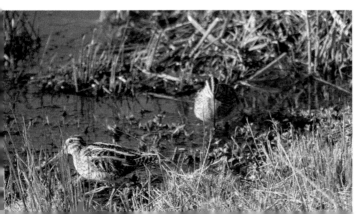

A pair of snipe forage for food on the shoreline of Plover Lake.

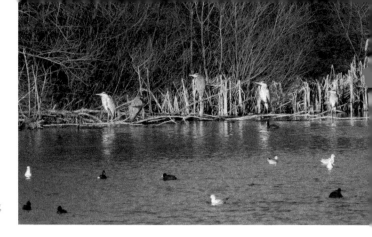

A siege of herons enjoying
the winter sun.

5 Ickworth House

Now in the care of the National Trust, Ickworth House, along with its 1,800-acre land and the family that once owned it, has had a long history. At the time of the Norman Conquest the land was in the ownership of Bury St Edmunds Abbey; however, the estate came into the ownership of the Hervey family in 1432, where it stayed for the next 500 years.

The fortunes of the Hervey family are worth mentioning. John Hervey became a baron in the opening years of the eighteenth century and was further rewarded by being made the Earl of Bristol in 1714. The 5th Earl was made the Marquess of Bristol in 1826.

The current Italianate house with its distinctive rotunda was commenced in the late eighteenth century and took forty-seven years to complete. In the 1950s the death duties on the estate were so colossal that the 4th Marquess gave most of the house – with the exception of the east wing – to the nation in lieu of tax. In the late 1990s, a few years before his premature death, the flamboyant 6th Marquess, who had squandered his immense inheritance, sold his lease and the right to live in the east wing to the National Trust for £100,000.

The east wing of Ickworth House is now a luxury hotel, while the west wing contains the National Trust's splendid tearooms and visitors' centre.

The grounds of the house are wonderful and contain many highlights, including the Italianate walled garden and the canal lake. A recent addition to the estate's treasures is its restored medieval church. The church was made redundant in the 1970s and had fallen into disrepair by the 1980s: however, the 8th Marquess created the Ickworth Church Conservation Trust, who restored it at the cost of £1 million, and it was reopened in summer 2013.

Details
Ickworth House is free to visit for members of the National Trust. For non-members there are separate entrance fees for the house and gardens. The house is located 3 miles to the south-east of Bury St Edmunds on the A143.

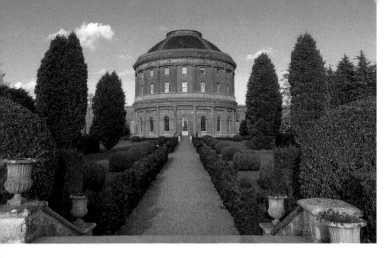

The handsome rotunda of Ickworth House under a blue sky on a freezing cold winter's day.

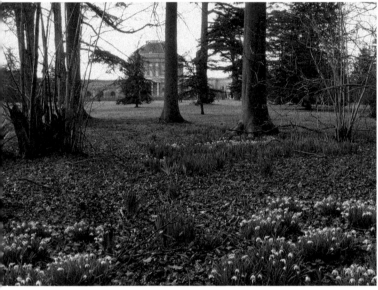

February's snowdrops in Lady Geraldine's Walk with Ickworth House in the distance.

6 Bury St Edmunds

As a young teenager I was a prolific reader of novels and a total bookworm. Rather than playing out, I used to spend my time curled up in an armchair devouring a good book. This was in the days long before there was a separate literary genre of teen fiction. Instead, I read lots of historical novels, including a trilogy that my young teenage mind took to heart as I avidly consumed it. Many of my classmates also read the trilogy and we spent our lunchtimes discussing the plots and characters. We were all keen young students studying kings, queens and battles, but in these books we found common everyday people with their lives and struggles – a heady mix for aspiring young social historians. Those books were Norah Lofts' 'Suffolk House Trilogy'.

My school in Gloucestershire was seemingly a world away from the landscape of Martin Reed's medieval serfdom, apprenticeship and wealthy wool merchant tale of Suffolk. In those days I did not appreciate that Norah Lofts' imaginary town of Baildon was based on medieval Bury St Edmunds and that other places she wrote about – such as Lavenham and Dunwich – existed. Nor that the fine medieval house Martin Reed built was in all likelihood a real fifteenth-century merchant's house in Suffolk's Hadleigh.

However, even with my (then) lack of knowledge about East Anglian towns, the books still lit the spark of a social historian within me. Thirty or so years on from my teenage years, and I've spent my adult life living geographically close to her world. So, while writing this book, it was time to revisit Norah Lofts' classic story.

Today, her trilogy has been brought to a fresh generation through the release in new e-book and audio book formats. With her book streaming vibrantly into my phone's earpiece, I strolled the streets of Bury St Edmunds to discover Norah Lofts and her fictional medieval town of Baildon.

Born in 1904 in Norfolk, Norah Ethel Robinson first moved to Bury St Edmunds in 1913. She married Geoffrey Lofts in 1933 and spent most of her life living in the town. After his death, she remarried in 1949.

In 1955, she bought Northgate House in Northgate Street where she lived until her death in 1983. From all appearances, her grand red-brick house appears to date from the Georgian period; however, the outside hides a sixteenth-century timber frame because the medieval house was gentrified in the 1700s – as was common throughout Suffolk's former wealthy medieval towns. While her Bury St Edmunds house was not the inspiration for the house in her trilogy, it is easy to her imagine her writing her tale within its walls.

Close to Norah Lofts' house are the grounds and atmospheric ruins of the former grand Benedictine abbey dedicated to St Edmunds, with its two surviving gatehouses. It is within the ruins of the abbey that her fictional account of medieval Baildon mingles with the real Bury St Edmunds.

Was the destitute serf Martin Reed collecting his alms from the imaginary monks of St Egberts, or was he collecting them from the real abbey dedicated to St Edmunds? Was he living in total poverty in the buttresses and ditches of Baildon's Squatters' Row, or did he live within the town walls of medieval Bury St Edmunds? Did the riot against the abbey happen in the fictional fifteenth-century St Egbert's Abbey, or was Norah Lofts writing about the genuine uprising that took place by the town against fourteenth-century Bury St Edmunds Abbey? Her intermingling of fiction with fact brings a tight-knitted narrative and a fully fleshed-out world that we can both empathise with and visualise.

The character of Martin Reed is said to be based on the town's wealthy medieval merchant, alderman and benefactor Jankyn Smith. He died in 1481, and under the terms of his will he gave various substantial financial gifts and endowments to the town. One gift eventually became the Guildhall Feoffment Trust, which founded a school of the same name in 1843. Norah Lofts herself was a pupil of the school when she first arrived in Bury St Edmunds and she later became a teacher at the same school.

Above: Northgate House in Northgate Street, Norah Lofts' house between 1955 and 1983. Attached to the house is a blue plaque from the Bury St Edmunds Society commemorating her life.

Left: Guildhall Feoffment Primary School in Bridewell Lane, where Norah Lofts was both a pupil and teacher.

Alderman Jankyn Smith also left money for a yearly Mass for his soul to be said in the parish church. Remarkably, even after the Reformation in the 1500s swept away similar Catholic Masses for the wealthy, a service is still held to this day to commemorate this philanthropist. On the anniversary of his death the people of Bury St Edmunds also give thanks for his life and then celebrate with cakes and ale.

Norah Lofts wrote over fifty books – some in her name, others using a pseudonym. There is no better time or place to return to (or read for the first time) Norah Lofts' trilogy of life in Suffolk than to do so while visiting Norman and medieval Bury St Edmunds.

Details
Bury St Edmunds is on the A14 between Newmarket and Stowmarket. There is plenty of car parking throughout the town, including short-stay parking within the town's medieval heart.

Bury St Edmunds Abbey's gatehouse. This was built some years after the original gatehouse was destroyed by rioting townsfolk in 1327. They were rioting against the domineering abbey and the abuse by the abbey of the town's rights. Norah Lofts skilfully wove fiction with fact in her narrative about her mythical fifteenth-century St Egbert's Abbey and how riots brought incredible prosperity to her medieval protagonist.

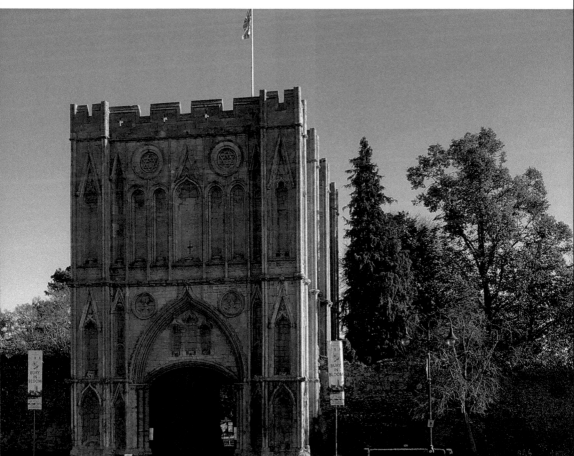

7 Bury St Edmunds Abbey

Suffolk proudly boasts that the town of Bury St Edmunds is the jewel of the county, a statement that the council have confidently proclaimed on numerous signs on the main approach roads into the town. It is a bold declaration and, in a county packed with superb jewels, an assertion that deserves full scrutiny.

There is nowhere more fitting to study the county's claim than the ruins of the town's ancient abbey. Now a well-kept garden appropriately called Abbey Gardens, the ruins are always full of dog walkers, joggers, children playing and, in the summer months, picnickers. Aside from the leisure activities to be enjoyed here, are the astounding remaining fragments and history of the once grand Bury St Edmunds Abbey.

The abbey was famed in medieval times for holding the relics of the martyred Anglo-Saxon king of East Anglia, Edmund the Martyr (also known as Saint Edmund). Attacking Danes murdered the king in 869 and his remains were brought in 903 to what was then a tiny religious community in the small town known as Beodericsworth.

From that time onwards the religious community grew in wealth and prosperity, resulting in the foundation of the abbey in 1020. It became one of the richest and most powerful Benedictine abbeys within England. A shrine was built to St Edmund during the eleventh century, which developed into an extraordinarily popular holy place for pilgrims to visit. Pilgrimages to holy places within England was a common pursuit for the devout in the Middle Ages, prior to the Reformation sweeping away such journeys.

The fortunes of Bury St Edmunds Abbey were not just due to the popularity of the shrine but also the town's relationship to the abbey, which Pevsner describes thus:

> It is generally, although not universally, agreed that King Edmund [king from 939–946] gave the town to the abbey in 945, and this area was a banleuca that came under direct control of the abbot – a tremendously privileged position. The fortunes of the town and the abbey were intertwined, resulting from time to time in disagreement and outright hostility, not least because the abbots exacted a payment of 100 marks (£66 13s 4d) upon the election of each new abbot.

The abbey was also influential with political events. In 1214, during the reign of King John, dissatisfied earls and barons gathered at the abbey to discuss their criticisms of the king. The following year, the barons notoriously forced the king to sign Magna Carta at Runnymede.

The abbey's wealth and fortunes ended during the reign of Henry VIII. In the 1530s, the king seized all religious houses within England – either peacefully or forcefully – and closed many, appropriating their wealth to his own royal coffers.

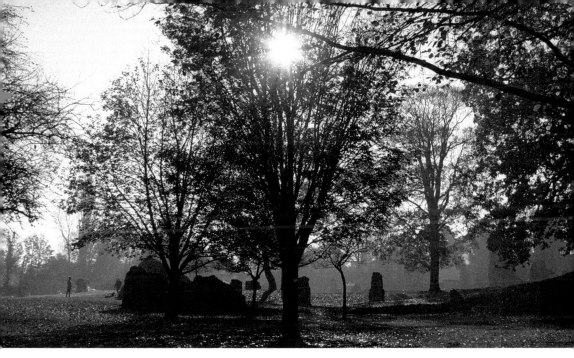

Above: In the early morning sun and the mist, the ruins look like ancient megalithic standing stones.

Below: A thousand years of history in a single photograph. In the foreground is the imposing abbey ruins. In the distance is St Edmundsbury Cathedral's tower, completed in 2005. Originally St James's parish church, it became a cathedral in 1914 and is Suffolk's only cathedral.

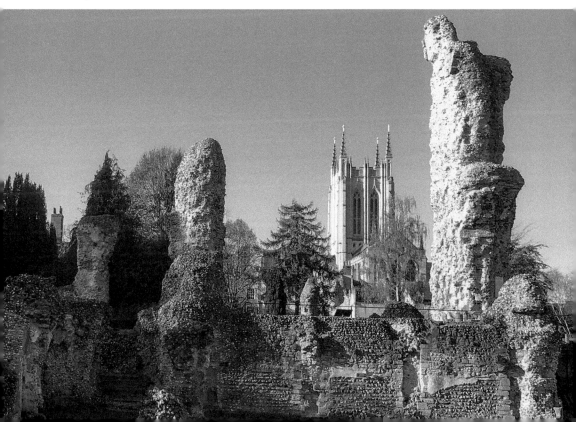

Bury St Edmunds Abbey surrendered to the king in 1539. The great abbey was no more, and over the centuries it fell into decay. No doubt material from this once-magnificent abbey was used as building matter for surrounding houses.

Today, the abbey's former fortunes can still be determined by the vast scale of its ruins and the evidence that the abbey's construction and craftsmanship was outstanding. Wandering around in half-light can be an unnerving experience. If only the walls could talk. What tales would they tell? No doubt stories of Norman monks and abbots, medieval pilgrims, discontent knights and barons, rioting townsfolk and the abbey's final days during the death throes of this once great institution.

As a unique postscript to the fortunes of the abbey, in recent years archaeologists have claimed that St Edmund's remains are still buried within the abbey's gardens. If a medieval king can be found in a car park in Leicester, then perhaps an Anglo-Saxon king will be discovered under tennis courts in Bury St Edmunds.

For its atmospheric and historic ruined abbey alone, Bury St Edmunds' claim to being the jewel of Suffolk is justifiable.

Details
The Abbey Gardens are in the centre of the town. There is short-stay car parking directly outside the gardens. Check the Internet for the opening times. Entrance to the gardens is free.

8 Knettishall Heath

In 2017, a spoof rumour emerged from Suffolk proclaiming that wolves were about to be reintroduced to Knettishall Heath, one of Suffolk's most important nature reserves. Notices were pinned up in the reserve, advising the heath's visitors to carry flare guns and not to walk on it after dark. The origination of the rumour is unknown, but the date of the announcement, 1 April, was no coincidence.

Fortunately, it was a hoax and wolves were not released. If they had been then it would not have been the first time in its long history that wolves (or more likely large hunting dogs) occupied Knettishall Heath. With its landscape dating back at least to the Bronze Age, 4,000 years ago, wolves would have been at home on the heath.

The heath was purchased by Suffolk Wildlife Trust in 2012. Parts of it is designated a Site of Special Scientific Interest (SSSI) because of its Breckland habitat. The Brecks is an area of Suffolk and Norfolk that claims to be one of the driest places in Britain and has a unique environment of forests, heathland and wildlife.

Wildlife that can be spotted at Knettishall Heath include lizards, rare birds, rare grassland plants, heathland plants, over 1,000 species of moths, and, most surprising

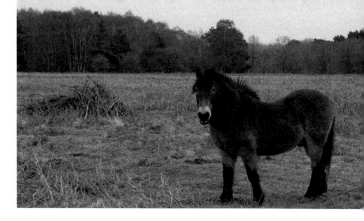

A curious Exmoor pony
stopped munching just long
enough for me to take a
photo.

of all, Exmoor ponies. The Breckland environment requires livestock to graze the
land to control its heathland and contain the unruly growth of bracken. For this
purpose, semi-wild Exmoor ponies were introduced onto the heath in 2012 as part
of its grazing programme. The ponies can freely roam and graze the area.

Knettishall Heath is also where four footpaths meet: Angles Way, Peddars Way,
Iceni Way and the ancient Icknield Way (claimed to be 'the oldest road in Britain').

Details
Knettishall Heath is 16 miles to the north-east of Bury St Edmunds and 7 miles
east of Thetford. There are several car parks within the nature reserve.

9 Bradfield Woods

Located between the villages of Felsham and Bradfield St George are Bradfield
Woods. The woods are comprised of two ancient woodlands, Felsham Hall Wood
and Monk's Park Wood. In the medieval period the monks of Bury St Edmund's
Abbey owned the latter, which was coppiced woodland approximately 220 acres
in size with a compartmented deer park.

By the 1970s Monk's Park Wood was nearly lost to agricultural development
and only a small proportion had survived the destruction. Influenced by Britain's
leading woodland naturalist and landscape historian, the late Suffolk-born
Oliver Rackham, who took great personal interest in the woods, local people
campaigned hard to save the remaining woodlands. It is only through their
diligence and perseverance that a small part of the original two woodlands were
saved and became a National Nature Reserve.

Today, the Suffolk Wildlife Trust manage the woodlands and they are
designated a Site of Special Scientific Interest.

The woods are packed full of woodland mammals and birds, deer, insects and wild
flowers. Over 370 plant species have been recorded in the woods. One such plant is
the rare and ancient yellow oxlip (often confused with cowslip), which can be seen in

the woods during the spring. In summer, butterflies and moths are in abundance and over twenty species of the former and 300 of latter have been recorded.

In winter, the trust maintains the woodland by rotational coppicing – the traditional method of managing woodland. Surviving documents detail that coppicing in Bradfield Woods has taken place since at least 1252, when the monks of Bury St Edmunds Abbey managed them. The woods today are Suffolk's largest area of coppiced woodland.

As well as an education centre, there is also an open-air workshop where many traditional woodcraft classes are held throughout the year for adults and children alike.

Details
Bradfield Woods is between the two villages of Felsham and Bradfield St George. There is a car park and visitors' centre at the entrance to the woods.

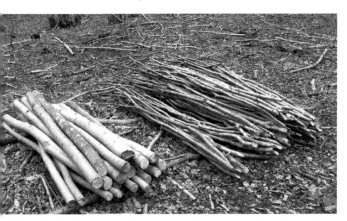

Left: Piles of wood coppiced during the winter.

Below: Bradfield Woods in late autumn.

South-West

10 Clare

The past is never far away when walking through the captivating town of Clare. Some of those bygone times are clearly visible; for example, the remains of a Norman flint and stone castle and the nineteenth-century Great Eastern Railway's disused buildings. Other detectible evidence of long-gone eras are not so obvious, such as the discovery in the village of prehistoric artefacts including signs of an Iron Age earth fortification, the traces of a Roman settlement, and Anglo-Saxon pottery.

Clare Castle was built by Richard de Clare or his son Gilbert and was first recorded in 1090. However, the castle's heyday was from the fourteenth to the sixteenth century. Pevsner states: 'Clare enjoyed something of a golden age under Elizabeth de Burgh, Countess of Ulster, founder of Clare College, Cambridge, whose principal home was Clare Castle from 1317 until her death in 1360.'

After Elizabeth de Burgh's death, the power from the castle declined but the town's prosperity continued with Suffolk's medieval and Tudor wool trade. However, once the wool trade finished, Clare, like so many of Suffolk's great medieval cloth towns, fell into disrepair. So much so that Samuel Richardson's 1742 edition of Daniel Defoe's *A Tour Thro' the Whole Island of Great Britain* stated that Clare 'is but a poor Town, and dirty, the Streets being unpaved'.

There was a slight revival in the town's fortunes when the Great Eastern Railway built a train station with its associated buildings, including a goods shed, in 1865. With the railway situated within the inner bailey of the castle, Victorian planners were obviously not vigilant about Clare's heritage.

The station stayed in the village until March 1967 when the train line ceased. The buildings, however, have remained and have now been incorporated into Clare Castle and Country Park. Outside the goods yard building is a crane. This is not the original crane from Clare's goods yard but another one that had once been used at nearby Glemsford's station and in recent years had been used on a farm. Glemsford's crane arrived at Clare's disused yard in 2004.

Despite the loss of the railway in the 1960s, the village has continued to flourish – to the extent that in 2015 it was placed in the top fifty 'Best Rural Places to Live in Britain' by the *Sunday Times*. According to the newspaper's judges, the town has 'period properties and rich history without the chocolate-box perfection'.

Today, Clare's heritage nestles side by side within its country park and throughout the town. There are over forty listed building that date from the sixteenth century or earlier, with a further eighty to ninety listed buildings from the seventeenth century onwards. There are also numerous antique shops, including the former maltings building, which is an Aladdin's cave of treasures and boasts fifty antique dealers within its premises.

Clare really is a delightful place to while away a few relaxing hours walking through the country park to explore the castle and disused railway station, and then on into the town to discover its rich heritage.

Details

Clare is 8 miles to the east of Long Melford. There is on-road parking by the marketplace or plenty of public pay-and-display parking within the country park.

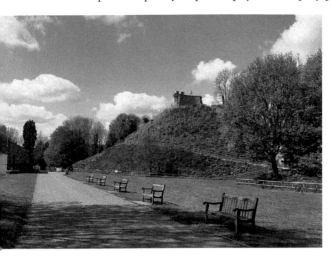

Clare Country Park with the Norman castle towering over the Victorian goods shed.

The view of the town from the top of the castle's mound. In the distance is St Peter's and St Paul's Church.

11 Cavendish

I often drive through the village of Cavendish – normally on my way to or from taking my son to school. The village certainly looks persuasive from my car window, but I am always in too much of a hurry to stop and take the time to explore. But even from my obscured view, I knew that it had to be included in this book as it is most certainly one of Suffolk's little gems. It was therefore with great delight that I stopped my car one spring morning after the school run to explore Cavendish.

The main focal point of the village is undoubtedly the large village green with its thatched cottages, almshouses and Norman church. In front of the church is a group of five pink thatched cottages. Formerly known as Church Cottages but now called Hyde Park Corner, they were built in the last quarter of the sixteenth century. They were in ruins by 1954 but were rescued from demolition by the artist Sir Alfred Munnings (the first president of the Cavendish Preservation Society), and in 1958 were refurbished by the conservation architect John Eric Miers MacGregor. In the early 1970s, the cottages were nearly destroyed by fire and once again had to be rebuilt. The cottages are still used today as almshouses; new residents must be aged over sixty with a connection to the village.

While the green is undoubtedly the village's central point, a stroll around the village shows there are plenty more buildings to delight, including over sixty buildings on the Statutory List of Buildings of Special Architectural or Historic Interest. One such listed building, Cavendish Hall, is a splendid Regency country house that can be hired out from its owners, the Landmark Trust, who restored the hall to its former glory with the help of a generous endowment.

Although a small village, Cavendish is certainly worth spending a while to explore and enjoy its scenery.

A characteristically English village green with its Norman church, public house and cluster of ancient thatched cottages. Victoria Cross hero Sir Leonard Cheshire (1917–92) is buried in the churchyard, as is his wife, Lady Sue Ryder, who founded the charity that bears her name.

Now residential apartments, this former mill was built in 1841 by Joseph Stammers Garrett. He was a miller, maltster, farmer and wealthy landowner. He also financed the village's Congregational Chapel and Lecture Hall.

Details

Cavendish is on the A1092, halfway between Clare and Long Melford. There are no public car parks, but there is plenty of roadside parking.

12 Long Melford

One of the most handsome villages in Suffolk, Long Melford has much to attract its discerning visitors. These attractions include two lavish Tudor manors (both open to the public), an eye-catching and majestic medieval wool church (surprisingly with an imposing late Victorian Gothic tower), a striking Tudor almshouse, pleasant greens, numerous grand medieval hall houses, and a rich industrial past.

Once known simply as Melford, it is plain to see how the village got its 'Long' prefix: its main road is a single continuous thoroughfare, starting at the High Street in the north and running for a further 3 miles through Hall Street before finally ending at St Mary's in the south. Most English towns and villages have their largest concentration of shops within a road named the High Street; however, in Long Melford's case, although the start of its major road is thus named, its shops are no longer located here but are further down in Hall Street and St Mary's.

Long Melford's medieval and Tudor past is all around, but it also has an industrial heritage originating from the eighteenth century with its heyday in the nineteenth century. The village's industrial trade included a flax mill with its associated scutching industry (the process of releasing fibres from raw flax that were made into Irish linen), a horsehair weaving factory, an iron foundry and a

coconut mat factory. The architecture of its industrial heritage mingles happily with its medieval and Tudor past. Adding to the overall cohesion of the village are the numerous trees that line the main road throughout.

Long Melford also has several connections to the literary world. Celebrated children's author and artist Beatrix Potter made many visits to Melford Hall as she was the cousin to Ethel Leech, the wife of the hall's owner, Sir William Hyde Parker. The author slept in the hall's West Bedroom and while there painted a series of watercolours. Melford Hall (now maintained by the National Trust) has several items on display that remember Beatrix Potter's visits to her Suffolk cousin.

Another storybook association is to the well-known children's book *Alice's Adventures in Wonderland*. It is thought that its illustrator, Sir John Tenniel (1820–1914), used a lavish stained-glass window depicting Elizabeth de Mowbray, Duchess of Norfolk, in Long Melford's Holy Trinity Church for the basis of his familiar Queen of Hearts illustration.

Long Melford's literary heritage continues at Mill House, the building adjacent to the eighteenth-century road bridge over the Chad Brook. It was here that the First World War poet and author Edmund Blunden (1896–1974) lived, who retold the horrors of his experience in the trenches in his classic book of memoirs *The Undertones of War*. He is buried in the churchyard at Long Melford's Holy Trinity Church.

Whether you are visiting the antique shops, manor houses, splendid wool church or stopping-off for a refreshing cuppa (or something stronger), Long Melford is a splendid place to visit. In a county stuffed full of jewels, because of the bountiful number of happy hours I've whirled away exploring its treasures, Long Melford is my third most cherished Suffolk gem.

The water conduit by Melford Hall looking back towards Holy Trinity Church. The conduit was originally built in the sixteenth century to supply Melford Hall with fresh spring water. Suffolk's fabled big skies are always on display at Long Melford.

Holy Trinity's imposing Victorian Gothic tower. The original medieval tower was struck by lightning in 1701 and was rebuilt 1712–25. It was encased in flint/stone and heightened in 1897–1903.

Details
Long Melford is a couple of miles to the north of Sudbury on the B1064. There is parking throughout the village – both at the roadside and in car parks. The manor house of Kentwell Hall is to the north of the village – privately owned and there is an admission charge. The village's other manor house, Melford Hall, is towards the middle of the village – owned by the National Trust and admission charges apply.

13 Sudbury Common Lands

A short walk from Sudbury's town centre and nestling alongside the River Stour are the town's Common Lands. This is a local nature reserve comprising of a series of interlinked commons, water meadows and wetlands criss-crossed with footpaths. Whatever the weather – sun, rain or snow – the Common Lands are always full of walkers, photographers and picnickers enjoying the scenery and country air.

Each changing season brings a profusion of wild flowers, birds, insects and other animals – from rare butterflies and dragonflies to swans and herons. Between spring and early autumn, cattle graze the water meadows.

Winter brings frost and ice, with snow sometimes forming a thick carpet over this tranquil riverside scene.

The Common Lands are now run by a charity founded in 1897, with trustees who use uniformed volunteer rangers to maintain and conserve the land. Each common or water meadow has its own unique name: North Meadow Common, Kings Marsh, Freeman's Great Common, Freeman's Little Common, and Great and Little Fullingpit Meadow.

The rights to graze cattle during the summer months by non-landowning townsfolk of Sudbury first happened in the late twelfth century when Amicia de Clare granted rights for the land known as Kingsmere (now Kings Marsh) and Portmanscroft (now Freeman's Little Common and Freeman's Great Common). Fullingpit Meadow was given to Sudbury Corporation in the 1730s for the use of freemen's cattle. Croft Bridge, linking the town with the meadows, was originally built in the 1790s so that the freeman could drive their cattle to Fullingpit Meadows. Today's freemen of Sudbury still enjoy the rights to graze cattle.

If you are hungry and thirsty after a long walk on the Common Lands, next to them is Sudbury's Water Mill, now a hotel and restaurant. William the Conqueror's great tax survey, Domesday, documented that there was a mill

St Gregory's Church from Freemen's Great Meadow. Curiously, the church houses the mummified skull of Simon of Sudbury, Archbishop of Canterbury who was murdered during the Peasants' Revolt on Tower Hill in London by rebels in 1381.

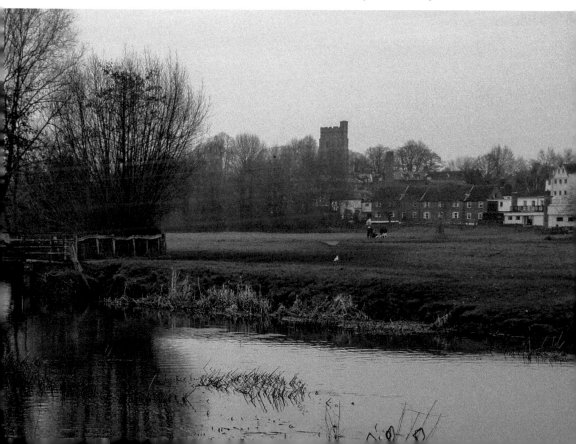

Two swans battle a wintery blizzard at the Old Bathing Place at Fullingpit Meadow. The concreted and regular pattern of the riverbank shows that this part of the river had a former life. Between the 1890s and the late 1930s this was the Bathing Place, an area for locals to brave the icy waters of the river for a refreshing swim. It was always busy with locals and had concrete steps into the river (the steps remain visible today) along with dressing compartments. An outbreak of diphtheria in the 1930s forced its permanent closure.

in Sudbury. The current mill is the likely location of the original pre-Norman one. The current mill was built in seventeenth and eighteenth centuries and still has its mill wheel – now placed behind glass within the restaurant.

Sudbury's Common Lands is one of those peaceful and relaxing places where sometimes you just need to sit and simply be, as the world and their dogs walk on by.

Details

Sudbury is located on the A134 and its Common Lands are situated along the River Stour to the west of the town centre. You can park in any of the town's car parks. The area is often waterlogged so remember to wear walking boots or wellies.

14 Lavenham

Walking through the medieval village of Lavenham, it is strange to realise that we nearly lost one of Suffolk's medieval gems. Much is known about its medieval past and that the wool trade brought great wealth to the area; however, it is little known that by the start of the twentieth century Lavenham was in serious decline.

The wool trade and its associated wealth had long vanished from the village, although new industry had sprung up in its wake. Thomas Turner (1784–1864), the master woolstapler, established a highly successful business and built rows of Georgian and Victorian cottages to house his workers. William Whittingham Roper (1820–90) and his sons subsequently built more workers' cottages and

horsehair factories. Other Victorian industrialists also built factories, mills and cottages in the village.

But even this new breed of merchant could not stop the decline in Lavenham's fortunes. Many of the village's medieval buildings had fallen into ruin or, worse still, had been destroyed. The manorial barn, which had given Barn Street its name, was demolished in the 1860s; the Guildhall of Holy Trinity in Prentice Street, one of the village's four medieval/Tudor guildhalls, was demolished in 1879; and the Guildhall of St Peter's, located on the High Street, was demolished at some unknown date. The village's two remaining guildhalls were not demolished but were in serious state of disrepair – their medieval heritage ignored.

The Guildhall of Our Lady (also known as the Wool Hall and today part of The Swan Hotel) had been divided into three houses and a baker's shop. It was in a dilapidated condition. The Guildhall of Corpus Christi, today the jewel in Lavenham's glittering crown, had in turn become a prison, a workhouse, an almshouse and a wool store. It was near derelict by the start of the twentieth century.

Other medieval buildings throughout the village had been entombed in red brick or plaster – a Georgian and Victorian habit of their wealthy owners. The intention was to 'improve' houses and hide their supposedly primitive rough medieval architecture.

Moreover, by the first quarter of the twentieth century other buildings in the village were being taken down, timber by timber, and moved elsewhere: Weavers House in Lady Street had been demolished and re-erected in Walberswick, and the Guildhall of Our Lady, De Vere House and Schilling Grange were in the process of being taken down to be re-erected elsewhere. It was only the outcry by local people, societies and prominent people that stopped this destruction. This outcry, along with the money and influence of people such as Queen Victoria's daughter, the Duchess of Argyll, stopped Lavenham's demise.

It was through these people's influence – not to mention their own personal wealth – that Lavenham was saved and individual medieval buildings were restored to their former glory.

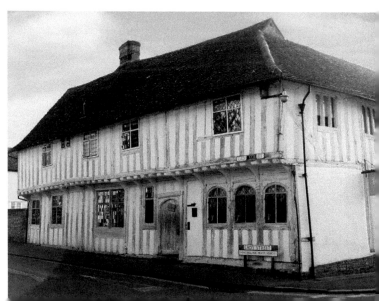

One of Lavenham's finest medieval buildings. Built in the fifteenth and sixteenth centuries, it was originally a range of shops. Over the centuries it has become a private residence and today is a restaurant.

Colourful row of Thomas Turner's workers' cottages built in 1856. Once home to Lavenham's industrial workforce, they are now mainly all holiday homes.

While Lavenham can no longer claim to be the fourteenth wealthiest town in England, it can assert itself as an outstanding tourist base for those seeking Suffolk's medieval, Tudor, Georgian and Victorian heritage.

Once when I was photographing the village a local man stopped me and after we had chatted awhile, he said: 'You don't know what's holding what up. Are the brick cottages and factories holding up the medieval houses, or are they holding up the cottages? Remove one and they'll all fall down.' He was quite right. Every single building in Lavenham is important to the cohesion and heritage of this jewel in Suffolk's crown.

Details
Lavenham is located 7 miles north-east of Sudbury. There are several car parks in the village, including one in the marketplace.

15 Monks Eleigh

Despite its name, there was never a monastic order within the chocolate-box village of Monks Eleigh. Instead, its name originates from the land ownership of the village prior to the Norman Conquest.

In 991, at the Battle of Maldon, the owner of the manor of Illeigh (or Illa), Byrhtnoth, an alderman of Essex, was killed. His widow, Ælfflæd, inherited his manor and under the terms of her will left it to the monks of the Benedictine cathedral priory of Christchurch, Canterbury. The monks owned the village's land, farms and houses. They also provided the village with Monks Eleigh's parish priests who served at the church dedicated to St Peter. Consequently, while there was not a monastery or other religious house in Monks Eleigh, this village does indeed derive its name from pre-Reformation Catholic monks.

Above: Monk Eleigh's enchanting village green complete with its medieval church and Victorian village water pump. Ransomes of Ipswich made the pump. It still has its stern Victorian notice: 'Boys or other persons damaging this pump will be prosecuted as the law directs.'

Right: The village sign, displaying that in the past monks from Christchurch Canterbury were very much a presence within the village.

In medieval times the village was a prosperous through its woollen and cloth trades. Several timber-framed buildings in the village, such as the Old Guildhall on The Street and Hobarts on Back Lane, date from this period of wealth. In 1541, Henry VIII confiscated the land from the Benedictine priory of Christchurch and gave it to the dean and chapter of Canterbury Cathedral, who remained the lords of the manor until the 1860s.

Today, nestling by a tributary of the River Brett, the village is one of the prettiest within Suffolk. It is well worth a visit to look at thatched cottages, the village green and medieval church. With a population of only 500 people, Monks Eleigh is small, but perfectly formed.

Details
Monks Eleigh is on the A1141, halfway between the villages of Chelsworth and Brent Eleigh.

16 Chelsworth

Nesting in the Brett Valley, Chelsworth is yet another of Suffolk's charming chocolate-box villages. It has had a variety of names over the last thousand years – including Ceorleswyrthe, Cerleswrda and Chellesworth – before it became Chelsworth.

Today's village has its foundations in the Anglo-Saxon period with its first documented evidence being a charter of AD 962 written in Latin. This recorded that the village and land of Ceorleswyrthe was given to Æthelflæd of Domerham by her stepson, King Edgar. Its Anglo-Saxon name meant 'Enclosure of the freeman or of a man called Ceorl'. The Domesday Book (1086) recorded that Cerleswrda had a church and a mill, and was owned by the Benedictine abbey of Bury St Edmunds.

The village is full of timber-framed hall houses and thatched cottages dating from the medieval and Tudor periods. Its outstanding collection of medieval buildings include The Grange, a fifteenth-century timber-framed, plastered former hall house that was once used as the parish church's rectory.

Opposite the village's pub is a red-brick bridge spanning the River Brett. Although it has the appearance of one bridge, it is comprised of two humpbacked bridges attached to each other. The northern bridge is thought to be the older of the two, while the southern bridge has a date plaque of 1754.

The colour of autumn on leaves and trees by the Georgian bridge over the River Brett.

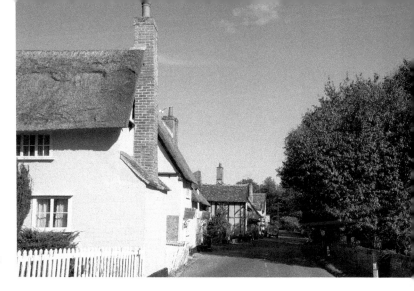

A small group of Chelsworth's thatched cottages and medieval timber-framed houses sit under a blue Suffolk sky.

Among the medieval and Tudor buildings, a strange item on the village's entry on the Statutory List of Buildings of Special Architectural or Historic Interest is that of the phone box outside the pub. The box is of the type known as K6, designed in 1935 by Sir Giles Gilbert Scott to commemorate the Silver Jubilee of George V.

This village really is one of Suffolk's hidden gems. Although it is only a tiny village, it is well worth parking up and exploring on foot, before retiring for refreshments in the village's sixteenth-century pub.

Details

Chelsworth lies on the A1141 between Hadleigh and Lavenham. The Georgian bridge over the Brett is extremely narrow and made more restricted by the use of modern width barrier posts. Only cars have the correct width to drive over it. There's on-road parking opposite the village's pub.

17 Kersey

Pevsner justifiably calls the village of Kersey 'the most picturesque village of south Suffolk'. It certainly is an alluring village whose picture was used on the lids of countless chocolate boxes throughout the nineteenth and twentieth centuries.

The village is bisected by its ford (known as 'the splash') located in a valley at the centre of the village and spans the River Brett. The village's main street rises from this valley, with two steep hills either side of the splash.

The parish consists of the village and four hamlets – William's Green, Kersey Upland, Kersey Tye and Wickerstreet Green. The parish's collection of medieval houses and buildings is remarkable. With the current population of just 350, to have over sixty buildings listed on the Statutory List of Buildings of Special Architectural or Historic Interest is extraordinary. Its collection of medieval

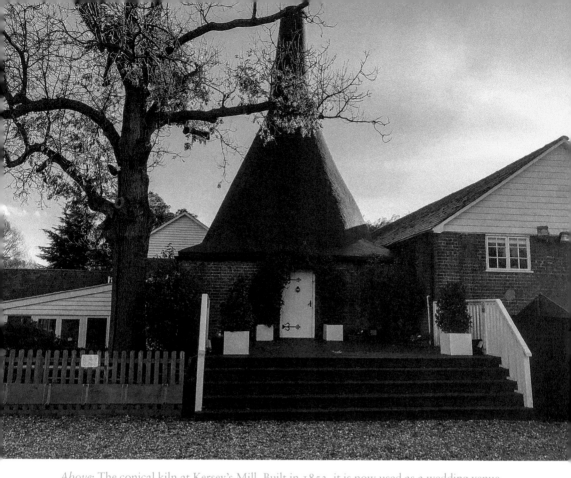

Above: The conical kiln at Kersey's Mill. Built in 1852, it is now used as a wedding venue.

Below: The village centre with its water splash over the River Brett.

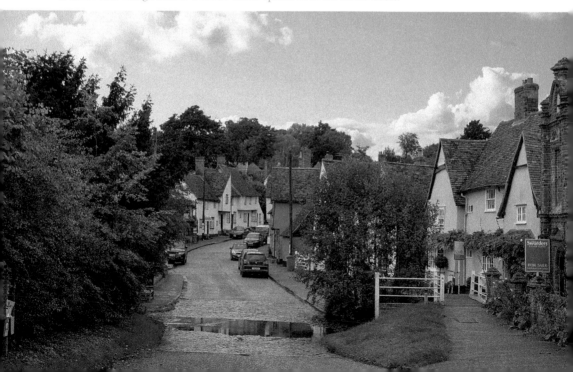

listed buildings ranges from the church (the earliest documented part, the north aisle, dates to 1335) to the late fourteenth-century The Bell Inn (the only surviving pub of the village's original three hostelries).

Much of Kersey's early medieval wealth was from the cloth industry, in particular from the manufacture of a coarse wool yarn and woollen cloth used for workers' clothes known as Kersey Cloth. It was eventually manufactured throughout England, but for some undocumented reason this Suffolk village gave its name to the cloth – perhaps because it was first made in Kersey.

A reflection of the times is that the village no longer contains any local shops. It was previously a bustling community with ample shops and trades such as shoemakers, tailors, blacksmiths, grocers, drapers, carpenters and bricklayers. There was even a coffin maker.

The parish also has more modern listed buildings, such as its Georgian mill, a large timber-framed and weatherboarded watermill built around 1810 on site of an earlier mill. The mill now contains a collection of local businesses and workshops, and is also licensed to conduct weddings. It is on the east side of the A1141, and is a nearly a mile from the village's centre so is often missed by tourists, but it is certainly worth a visit to look at the mill's grand industrial architecture and to sample the wares of the shops and businesses contained within.

Details

The village is located in-between Hadleigh and Lavenham a short distance from the A1141. Kersey's village is located on the west side of the A1141, while the mill with its artisan shops is on the east side. There is roadside parking in the village and a large car park at the mill.

18 St James' Chapel, Lindsey

One of the more surprising fragments of Suffolk's Norman history is that there was once a motte-and-bailey castle in the village of Lindsey. There are few remnants of the castle today – it is thought to have been discarded during the thirteenth century – and not much remains apart from a few minor earthworks. However, there is one building that once belonged to the castle that today remains virtually intact: St James' Chapel.

A tiny but perfectly formed religious chapel, it was built and used by the castle's residents. Long after the castle had been deserted, the chapel continued its use for religious purposes, although in much reduced circumstances. During the medieval period, it in all likeliness became a collegiate chapel (a college of Catholic canons) whose role was to sing Masses and offer prayers for the souls of deceased wealthy benefactors and their families. It ceased being a religious

establishment in 1547 by commissioners of Edward VI, the boy king who was England's first Protestant monarch. By closing this and other similar chapels, the short-lived king finished the work his father had started in the 1530s when Henry VIII dissolved the monasteries within England. From this time until the 1930s, the former chapel was used as a barn. In 1930, the chapel was given to the nation by the then owner of the land. It is now in the care of English Heritage.

Today, it is difficult to see the overall raw splendour of the chapel, with its flint walls and thatched roof, as the chapel is in the grounds of the Victorian private residence Chapel House. However, there is a narrow alleyway leading from the main road to the door of the chapel that is accessible for visitors.

Once inside, a quiet and peaceful world opens. The chapel is bare, with simple benches and table for furniture and earth on the floor. But it is serenely tranquil, if not a little damp on a winter's day.

Unfortunately, the only real glimpse of the chapel's entire outside structure is by looking over the entrance gate of Chapel House. However, I suspect that the residents of the house are used to the numerous pilgrims that visit this ancient chapel and peer over their garden gate.

Details

The chapel is open to the public all-year round – check the English Heritage website for any specific closures. The chapel is a short distance to the north-west of Kersey. There is very limited parking on the road.

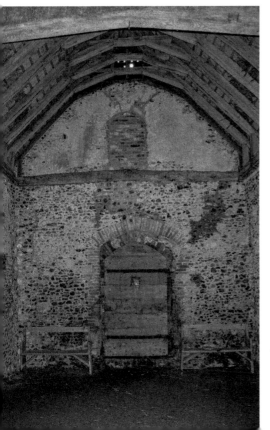

The interior of the simple chapel.

19 Hadleigh

One of Suffolk's great medieval wool towns is that of Hadleigh. The town's sign with its Pachal lamb standing above three woolpacks, demonstrates the importance of wool to the town's fortunes. Because of this affluent industry, the town is crammed full of medieval public buildings, timber-framed great hall houses and wealthy merchant's dwellings.

By the time of the 1377 poll tax, Hadleigh was the thirty-ninth largest town in England, with approximately 917 taxpayers. However, despite its size, its wealth was not substantial enough to be classified as one of England's top fifty wealthiest towns.

Hadleigh's fortunes had increased dramatically by the time of Henry VIII's lay subsidy tax of 1524/25. This time, the town's taxpayers were taxed £109 to pay for Henry's wars with France and was twenty-third in the rank of English towns' wealth. Remarkably, Hadleigh was wealthier than places such as Oxford and Cambridge. Curiously, the town's population in 1524/25 was ranked at only thirty-fourth place; this demonstrates that Hadleigh's wealth was increasing, but not in proportion to its growth in population. Moreover, its prosperity had increased substantially between 1377 and 1524/25.

In the 1570s, the Elizabethan antiquarian William Camden wrote of Hadleigh: 'Hadley, in the Saxons language Headlege, is watered with the same brook

The Guildhall in the grounds of the parish church. The sections on the left and middle were built between 1438 and 1451. The left section was originally the same height as the middle. The right section was rebuilt in the nineteenth century after a gale destroyed the original medieval building.

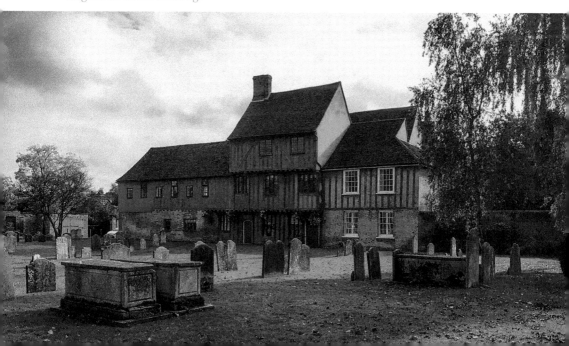

[River Brett]: a town of good note in these daies of making of clothes, and in old time much mentioned by our Historians because Guthrum or Gormo the Dane was heere buried.'

However, Hadleigh's fortunes declined from the eighteenth century onwards, like so many of Suffolk's other medieval wool towns. Consequently, the town was only lightly gentrified and modernised with new houses and industrial buildings. This drop in the town's fortunes meant that the medieval houses were left alone to large extent to gently rot throughout the eighteenth and early nineteenth centuries.

Hadleigh's decline is our good fortune. Today there is still an abundance of ancient houses that are being well maintained, and their continuing preservation is of upmost importance to their residents.

Details
Hadleigh is located halfway between Ipswich and Sudbury. There are plenty of car parks in the town centre.

One of Hadleigh's fine timber-framed hall houses. This one is in George Street.

South-East

20 East Bergholt

A delightful place on the Essex/Suffolk borders, East Bergholt is famous as being the birthplace of that most quintessential of British landscape artists, John Constable (1776–1837). Constable had great affection for his home village and painted several pictures of it, including *The Church Porch*, *Fen Lane* and *East Bergholt House*. Constable's birthplace, East Bergholt House, was demolished in around 1840, but his studio – Moss Cottage, used by him from 1802 onwards – remains. Up until the end of the seventeenth century, the village had a prosperous cloth-making industry and there are still several cottages and houses remaining in the village from this period in the village's history.

The village is also famed for its sixteenth-century bell cage, housing the parish church's bells. St Mary the Virgin Parish Church was to have a grand church tower built in the 1520s, financed partially with the help of Cardinal

Moss Cottage, John Constable's studio.

The sixteenth-century bell cage that houses the church's bells.

Thomas Wolsey (*c.* 1473–1530). However, Wolsey's downfall at the hands of Henry VIII meant that the church's tower was not forthcoming. Instead, in 1531 a temporary cage was built next to the church to hold the parish's bells. This bell cage was meant to be a short-term measure to the problem of the parish's church bells; however, it remains to this day and is still in constant use.

When walking around the village, despite the development of the last couple of centuries, it is easy to imagine the landscape and daily scenes Constable saw during his life.

Details

East Bergholt is a short distance from the A12. There is limited on-road parking within the village. John Constable's studio is now privately owned but there are plenty of opportunities for photographs outside.

21 Flatford

Time has stood still in the tiny hamlet of Flatford, with its scattering of buildings including a mill, cottages, granary and medieval hall house, remaining much as it was in John Constable's day. One of his most recognised landscapes, *The Hay-Wain*, depicts the scene outside his father's (Golding Constable) mill in Flatford. In 1821, after he had first created several sketches of the scene and a full-sized sketch in oil, Constable painted his iconic landscape in his studio in London.

Flatford Mill was purchased by John Constable's great-uncle, Abram Constable, in the mid-eighteenth century. Abram rebuilt the mill in the 1750s and today's exterior is much as it was then. The mill stayed in the ownership of the Constable family until John's brother (also called Abram Constable) sold the mill in 1846 for the extremely large sum of 2,000 guineas. During his father's time at the mill, John Constable worked there for a short time.

On the other side of the mill's stream is Willy Lott's Cottage. Known originally as Gibeon's Gate Farm (or Gibbonsgate Farm), the cottage was built in the late seventeenth century as a timber-framed hall house. Willy Lott, a tenant farmer and friend of the Constables, lived his entire life in the cottage. In the 1820s, he bought the lease to the cottage and continued to live there until his death in 1849.

Both Flatford Mill and Gibeon's Gate Farm had declining fortunes in the nineteenth century, so that both buildings were near derelict and much dilapidated by the 1920s. An Ipswich builder named Thomas Robert Parkington bought both buildings in 1926 and undertook limited repairs, including stripping out the mill's machinery and waterwheel. A revival in the paintings of John Constable saw the farm renamed to Willy Lott's Cottage. On Parkington's death in 1943 both buildings came into the ownership of the National Trust, who leased them to the Field Studies Council in 1946.

Close to the mill is Valley Farm, the oldest building in Flatford. An early fifteenth-century timber-framed, open great hall house, it was built for a wealthy yeoman farmer. When it was first constructed the house did not have an upper floor or a fireplace with a chimney. Instead, fires were built on the stone floor and the smoke drifted upwards, escaping out through the roof tiles. Sometime in the sixteenth century a sizeable inglenook fireplace and chimney were built, and an upper floor added to provide bedrooms. Willy Lott was born in Valley Farm and the ownership of the farm stayed with the Lott family until 1901. The house was in private ownership in the first half of the twentieth century, until it was sold to the Society for the Protection of Ancient Buildings in 1935 for £1,500. The society restored the building to its original state and removed the upper floor, but left the Tudor inglenook fireplace. The farm was leased to the Field Studies Council and in 1959 the National Trust purchased the farm, with the council remaining as a tenant.

The morning sunlight casting shadows on the bridge next to Flatford Bridge Cottage. Constable captured part of this cottage in his painting *Landscape with Boys Fishing*. A small preparatory sketch of it measuring 16 cm by 24 cm and entitled *Flatford Lock on the Stour looking towards Bridge Cottage* was sold at auction for £720,000 in 2016.

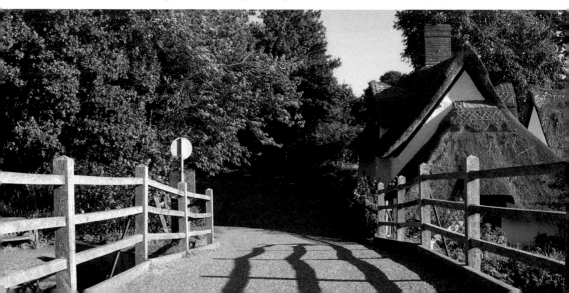

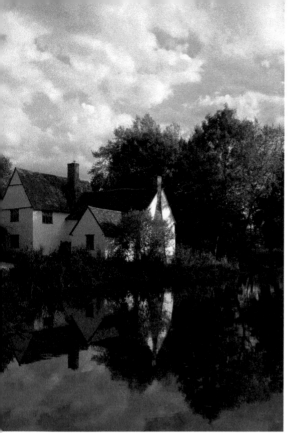

Above left: Not a hay wain in sight, but the ghost of Willy Lott, family friend of the Constables, lives on in the farmhouse.

Above right: Everything in Flatford is idyllic, including the walk from the National Trust's car park to the hamlet. In autumn the walk becomes a kaleidoscope of reds, golds and yellows.

Today, Flatford is an enchanting hamlet. It is always full of tourists seeking Constable's iconic buildings and students (young and old) attending the Field Studies Council's courses. Willy Lott's Cottage is probably one of the most photographed locations in Suffolk. Fine photographs of Constable's Suffolk can be achieved here – if you can dodge the constant stream of visitors around the mill and Willy Lott's Cottage.

Details

There is a large National Trust car park at Flatford (free to members). Close to the car park is an exhibition centre (with toilets) and an excellent tearoom. Willy Lott's Cottage, Flatford Mill and Valley Farm are owned by the National Trust and leased to the Field Studies Council. They are not normally open to the public; however, if you want to see inside the buildings, book yourselves onto one of the council's splendid courses. The courses are wide ranging and include photography, painting and birdwatching. If you book a residential course, you may be lucky enough to sleep in Willy Lott's Cottage. The National Trust occasionally have tours and open days of all three buildings – check their website for details.

22 Shotley

On the very tip of the Shotley Peninsula is the coastal village that gives the name to the peninsula. On first appearance, the village appears to be very small, with few houses, two pubs and a village shop. However, after an almighty high court battle, more houses, shops, offices and community facilities will be built within the grounds of the former HMS *Ganges* in the coming years.

HMS *Ganges*, the Royal Navy land-based training school for boys, closed in 1976. There are now very few buildings that remain from its time. However, of great interest is the small but extensively stocked HMS Ganges Museum. The museum themselves state: '160,000 boys went through the gates as boys and marched out as men, from its inception as a Royal Navy Training Establishment in 1905 to its closure in 1976.'

The museum is extremely successful in preserving the history of HMS *Ganges*; its archive of photographs is astounding. If your Royal Navy relative or ancestor spent time at HMS *Ganges*, then the museum is an absolute must to visit. In among their collection of thousands of photographs, you might just spot your relative. The museum also holds many original artefacts from the long history of this Royal Navy establishment.

Shotley is also ideal for boat and ship watching. To the uninitiated (such as myself) it takes – with the help of a map – a short time to work out that you are

Yacht sailing into Shotley Marina. In the distance are the ports of two counties: by the giant cranes on the left lies Suffolk's Felixstowe, and to the right is Essex's Harwich. The red of a Trinity House light vessel can be seen in the channel between Felixstowe and Harwich.

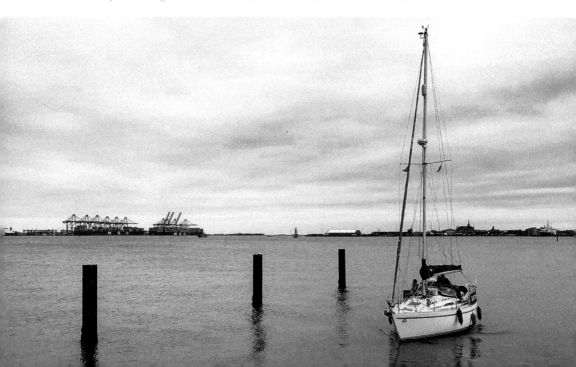

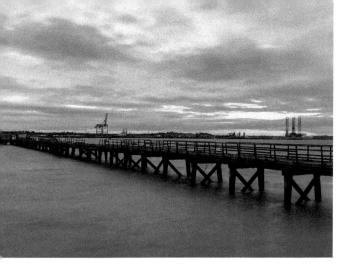

The Victorian railway pier at Shotley with the port and ferries of Harwich in the distance. There are currently plans afoot to restore the pier to its former glory, financed by public subscription.

viewing two coastal towns from Shotley in two separate counties. And, as well as the North Sea, you are also viewing two of Suffolk's major rivers: the Orwell and the Stour. The large container ships opposite Shotley's marina – seemingly a short hop away – are in Felixstowe, and across the water opposite the Bristol Arms pub, is the port of Harwich.

In front of the Bristol Arms is a dilapidated Victorian railway pier built by the pub's namesake, the Marquess of Bristol, in 1894. The Royal Mail used the pier to connect Shotley to Harwich via ferry.

Shotley has a claim to literary fame in Arthur Ransome's *We Didn't Mean to Go to Sea*. The father of the Walker children was a Royal Navy officer and received a posting to Shotley – hence why the children were staying at Pin Mill. Shotley's pier is also mentioned in the novel, when the children anchored by it for the night.

Shotley is a perfect place to spend time and ponder its rich maritime and naval heritage.

Details

Shotley is located at the end of the Shotley Peninsula and the B1456. The old pier is opposite the Bristol Arms and there is parking next to the pier. Follow the road past the pub towards Shotley Marina. HMS Ganges Museum and the former Royal Navy site is in the marina. There is ample public car parking.

23 Shotley Royal Naval Cemeteries

It would take a person with a heart of stone not to be visibly moved by the serenely peaceful twentieth-century Royal Naval Cemeteries next to Shotley's medieval church. There are two such cemeteries at St Mary's: one is within the churchyard itself and the other across the way from the church in its own

secluded part of the hamlet's cemetery. It seems fitting that this, their final resting place, overlooks the staggering beauty of the river and sea, near to where so many buried here met with their deaths.

Apart from during the Second World War, from the early 1900s until 1976 the Royal Navy's land-based training establishment HMS *Ganges* was based at nearby Shotley Gate. HMS *Ganges*' purpose was to train boys ready to serve as members of the Royal Navy. The countless pre-First World War and interwar naval graves and memorials within St Mary's Churchyard bear testament to the dangers of accident or illness at peacetime HMS *Ganges*.

St Mary's Churchyard also contains the graves of 205 boys and men (including twelve men from the German Navy) killed during the First World War, and thirty men from the Second World War. Heartbreakingly, First World War burials include six fifteen-year-old boys and twenty-three sixteen year olds. Other deaths include men killed at sea on submarines, torpedo boats and minesweepers.

Across the road from the church is the Second World War's Commonwealth War Grave Commission's Royal Naval Cemetery. By 1940, St Mary's Churchyard ran out of room for naval burials so a plot of land next to the church was purchased by Admiralty and used for a new Royal Naval Cemetery. Once again, the individual stories of the men who lie in this cemetery tell the story of heroism, suffering, loss and bereavement. In this cemetery, Sir Reginald Bloomfield's iconic Cross of Sacrifice rises above the graves of ninety-six men from Britain, and five Dutch men from the Netherlands Navy.

Each death in these two war cemeteries is a piece of unimaginable tragedy for their bereaved families. As one Second World War grave's epitaphs states: 'His life a beautiful memory. His death a silent grief.'

All you can do is stand at their gravesides in silent reflection.

Second World War Royal Naval Cemetery. In the distance are the gigantic cranes and container ships from the Port of Felixstowe.

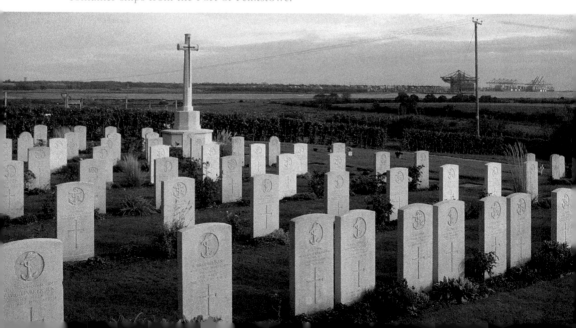

Details

Shotley's church is located on an unclassified road between Chelmondiston and Shotley. It is signposted from the B1456. There are two car parks by the church. One car park is at the end of an unmade road and has clear signposts next to the church, the other is directly opposite the main entrance.

24 Pin Mill

In the mid-1930s, Arthur Ransome, the author of classic children's sailing adventures, moved from the Lake District to Suffolk. In 1934, he bought a 28-foot, 7-ton rigged sailing cutter for £525 from a boatyard in Sussex and sailed her to her new home at Pin Mill. He renamed the yacht *Nancy Blackett*, after one of his characters in his extremely successful book.

The *Nancy Blackett*, Pin Mill and the River Orwell then became the basis for a new story about the Walker children, who he had first brought to life in *Swallows and Amazons*. This time his four young protagonists accidently cross the North Sea to Vlissingen in Holland, after a sailing trip on the River Orwell from Pin Mill to Shotley and Harwich Harbour turns disastrously wrong.

In the eighty years since its first publication, *We Didn't Mean to Go Sea*, is still a popular and much-loved children's book. Much of its enduring appeal is not just the well-written adventure story that it is, but also the picture that Ransome painted of Pin Mill and the River Orwell through his inspired writings. As background research for the book, Ransome himself took a similar trip to the children. This enabled him to bring the sights, sounds and experiences of sailing from Pin Mill to Holland vividly to life.

Following in his footsteps, I listened to Ransome's tale on talking books as I drove through the Shotley Peninsula to research and photograph this book. The story is as exciting now as it was when he first wrote it. Moreover, Arthur Ransome's 1930s Pin Mill is more or less the same today. Alma Cottage, where the children stayed, is a real-life holiday cottage with breathtaking views over the River Orwell. The seventeenth-century timber-framed smugglers inn, the Butt and Oyster, on the waterfront is also a genuine watering hole. Even the *Nancy Blackett* can sometimes be spied at Pin Mill as she is now owned by a trust dedicated to both preserving the yacht and continuing the legacy of Arthur Ransome's East Coast tales.

Although the book is billed as a child's adventure story, its appeal is for all ages. John, Roger, Tilly and Susan might not have meant to go to sea and we may no longer live in a world of telegrams and a Royal Navy base at Shotley, but many readers old and young alike are very glad that they did. Arthur Ransome's yarn of sailing and jolly japes still captivates the minds and spirit of today's audiences – particularly when at Pin Mill and the River Orwell.

The pink building on the right is part of Alma Cottage, where the children in Arthur Ransome's book stayed. In the distance overlooking the River Orwell is the Butt and Oyster Inn.

Details

Pin Mill is a riverside hamlet on the River Orwell to the north of the village of Chelmondiston. There is a well-signposted single-track lane from Chelmondiston to the river and a small public car park and on-road parking at Pin Mill. The pub also has its own car park. In good weather and at weekends Pin Mill is extremely popular. It is often less fraught to park in Chelmondiston and walk to the river.

25 Woolverstone

A few miles from the Orwell Bridge and within the Shotley Peninsula is the small parish of Woolverstone. The village is split into two sections and divided by the main road that runs through the peninsula – the B1456. The section of the village on the B1456 is very small but does contain some buildings of historic interest, including Woolvestone Hall. This is a Grade I-listed building, built in 1776 as the country home of the local landowner William Berners. Today, the hall is the home of the independent day school Ipswich High School.

To the north of the village, a road leads down to the riverside. Here, the village becomes a hive of bustling activity with its marina and Royal Harwich Yacht Club. With a tiny resident population of only nearly 300 people, the village's size swells considerably each day with day trippers visiting the riverside and boats arriving via the River Orwell.

If you are like me and not a yacht person, then there is still plenty of people watching and boat watching to be done from the comfort of the marina's well-stocked riverside bar and restaurant.

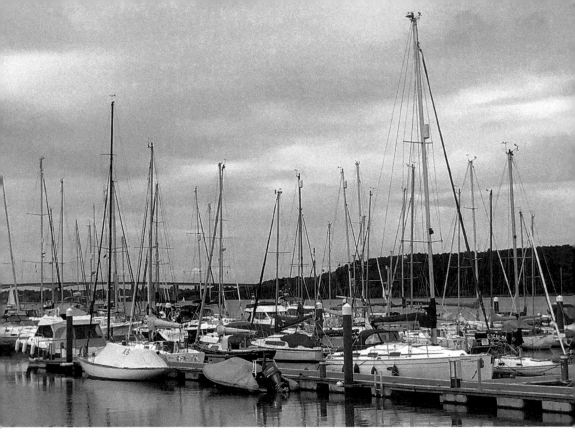

Above: Boats in Woolverstone's marina with the Orwell Bridge looming in the far distance.

Left: The Royal Harwich Yacht Club and the River Orwell at Woolverstone.

Details
The village of Woolverstone is approximately 4 miles south of Ipswich on the B1456. The riverside, marina and yacht club are in the north of the village and signposted from the main road. There is plenty of public car parking just before the yacht club.

26 Orwell Bridge

In a book about the gems of Suffolk that include medieval wonders and nature's marvels, it may seem strange to include a modern road bridge. However, I would argue that as you can hardly miss it and it is a vital part of Suffolk's daily life, it is a modern-day gem. Whether you are driving over the bridge or viewing it from the alluring villages and hamlets of the Shotley Peninsula, the Orwell Bridge is certainly a Suffolk landmark.

Construction of the bridge started in 1979 and it opened in December 1982. With eighteen spans, its total length is 1,287 metres, and its main span is 190 metres in length. In 2017, Highways England stated that there was a daily average of 55,000 vehicles per day. As many visitors to this part of Suffolk know, closure of the bridge for any reason causes major disruption to homes and businesses in the area. Maintenance is regularly carried out on the structure with engineers and crew seemingly to take their lives into their hands by abseiling down the structure onto piers and balancing precariously in steel cages under the bridge. Like it or loath it, the Orwell Bridge is certainly here to stay and for its remarkable feat of engineering is a worthy inclusion into this book.

Details

The Orwell Bridge is located south of Ipswich and is the part of the main A14 route over the River Orwell. It is best viewed from below the bridge at any of the riverside locations along the B1456, which runs along the Shotley Peninsula. There are several laybys for cars a few metres south of the bridge on the B1456.

A yacht sails in the River Orwell under the bridge, while a Maesrsk Sealand lorry from the Port of Felixstowe drives over the bridge.

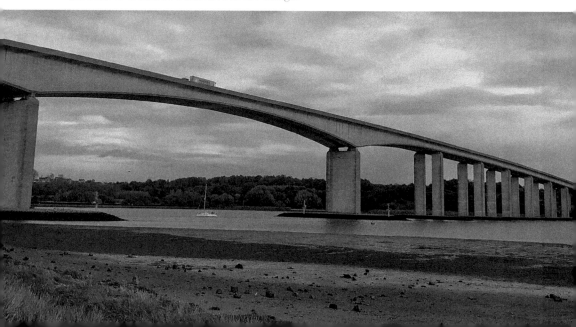

27 Ipswich Waterfront

In the last decade or so the historic docklands of the port of Ipswich has rebranded itself with a new name of Ipswich Waterfront. The rebranding has not met with universal approval; one reviewer on Tripadvisor has caustically remarked: 'It's the docks! Really winds me up with all this waterfront nonsense, it's the docks and always will be the docks!'

The docks have a long history in Ipswich. The Anglo-Saxons established the town – then known as Gyppeswyck – between AD 450 and AD 600 on the River Orwell. Ipswich became an important town with its fortunes based on the port's prosperity.

During the medieval period, Ipswich's docks were important to the Suffolk's wool industry by shipping wool to Flanders and the Netherlands. By 1377, poll tax records demonstrate that Ipswich was the twenty-sixth largest town in England with 1,507 taxpayers. Other taxation records show that Ipswich had risen to the twentieth largest in 1524–25, and to sixth place in 1662. Its taxable wealth was considerable too – the seventeenth wealthiest town in 1334 and seventh wealthiest in 1524–25. These figures show that Ipswich's wealth and size was increasing century by century.

However, once the prosperous medieval wool trade had ended, Ipswich, like many of English ports had to find other trades. Daniel Defoe, writing in the 1720s observed that

> Just before the late Dutch Wars [i.e. 1650s–70s], Ipswich was a town of very good business; particularly it was the greatest: town in England for large colliers or coal-ships, employed between Newcastle and London: Also they built the biggest: ships and the best, for the said fetching of coals of any that were employed in that trade: They built also there so prodigious strong, that it was an ordinary thing for an Ipswich collier, if no disaster happened to him, to reign (as seamen call it) forty or fifty years, and more.

This affluent trade ended by the time of Defoe's visit, resulting in him noting that Ipswich was by then in decline and decay. The deterioration in the town's fortunes was not helped by the quay and riverside drying out at low tide to such an extent that larger ships had to unload their goods some 3 miles downriver. The solution was to build Ipswich's wet dock, which was built during the 1830s and opened in 1842.

During the twentieth century, the docks became noted for the import and export of grain. Changes were made to the docks, including new maltings, flour mills, warehouses and bridges. However, by the end of the twentieth century Ipswich Docks, like so many across England, was in serious decline, with much of its maltings trade mechanised elsewhere.

The regeneration of the docklands started in the late 1990s and is an ongoing and continuing task. Some old buildings have been demolished, while other old

commercial warehouses, maltings and industrial buildings have been transformed into upmarket bars, hotels and apartment blocks. New apartment blocks have been built and part of the old wet dock has been transformed into a marina. Educational establishments have also taken the area to heart and there are extensive university and colleges buildings housing the University of Suffolk and Suffolk New College. This gives the entire dockland area the feeling of energy and vibrancy, though this revival is far from complete, with several buildings still shells or in ruins.

Whether they are known as Ipswich Docks or Waterfront, this part of Ipswich is an interesting location to visit, with its mix of old commercial dockland coupled with a new vitality.

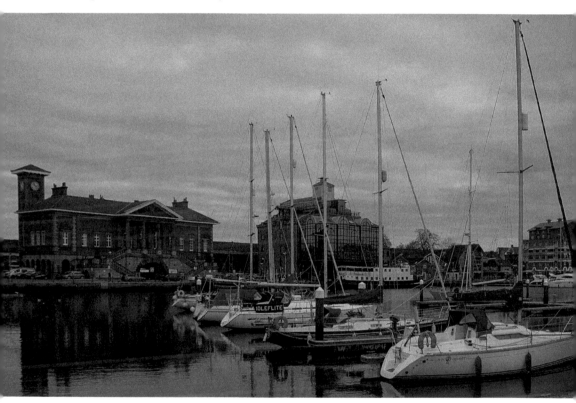

Above: In the distance is Ipswich Dock's Old Custom House, with its Italianate clock tower. It was completed in 1845.

Right: Waterfront cafés, bars and Salthouse Harbour hotel. These buildings were once merchants' houses and warehouses.

Details

Ipswich Waterfront is in the middle of town and there are plenty of car parks nearby. Alternatively, there is a small number of roadside parking spaces within the Waterfront area.

28 Landguard Fort

Now maintained by English Heritage, the important military fort at Landguard Point is testament to 500 years of intermittent wars and the need to defend the east coast of England and Britain from foreign attack.

There has been a military fort in this part of Suffolk since the 1540s and the reign of Henry VIII. The first fort, consisting of two blockhouses, was developed between 1545 and 1588 but nothing remains of this Tudor structure.

The second fort was built in 1628 and was square shaped with bastions at each corner. During the Second Anglo-Dutch War, the Dutch attacked the fort in 1667. Despite sending 1,500 Dutch marines and 500 sailors, the attack was unsuccessful and Languard Fort (and England) withstood the assault. This battle was the last time a foreign power landed uninvited on mainland Britain to launch an attack on the country.

The third fort was built in 1717 but did not endure for many years before the fourth one was built in 1744. This fourth fort used a pentagonal bastion design that completely protected the fortress and surrounding area. The fort was once again extensively rebuilt and remodelled in the 1870s but some of the features from the 1740s fort were kept.

The 1871 census has a snapshot in time of the people who lived in the fort approximately at the start of its Victorian rebuilding. The census recorded that there were ninety people living in the fort – men, women and children. The commanding officer was James M. V. Cotton, captain of the 27th Regiment of Foot. This was an Irish infantry regiment of the British Army and the census reveals that many of the 1871 soldiers were born in Ireland.

The fort housed the captain, two lieutenants (one the adjutant, and the other the superintendent of works), a doctor with his family and servants, a colour sergeant with his family, thirty-nine soldiers (two with their wives and children), six gunners from the Royal Artillery (all with their families), one royal engineer (who was the military foreman of works), a sergeant from the Army Hospital Corps, and a civil foreman of works and a civil stonemason. The nearby Martello tower also housed a gunner with his family.

The number of soldiers increased after the Victorian rebuilding works. By 1911, a few years before the First World War, there were 177 officers and men

with a further fifty-one other people (including wives, children, servants and civilian staff) present in the fort.

The fort remained as an operational military establishment during the First and Second World Wars with many regiments in residence during both hostilities. Today, many of the interior rooms and barracks have exhibitions of Landguard during both world wars.

Landguard Fort is an extraordinary construction. From small children investigating the gargantuan guns and the labyrinth of rooms, to intense military historians, there are hours of interest and fascination for everyone. Moreover, on a cold and windy winter's day, it is easy to imagine the harsh military conditions within the fort and to hear on the parade ground the ghosts of Victorian soldiers' pounding feet.

Right: The date plaque reads 1875 – after the Victorians rebuilt and remodelled the Georgian fort. The Victorian fort was the fifth to be built at Landguard.

Below: The inner parade ground and the 1870s soldiers' barracks.

Details

Landguard Fort is at the end of the A14. After the A14 ends, follow the A154 almost to the centre of town. Then at the town's traffic lights turn right and follow signs to the fort, where there is free parking. English Heritage's admission charges apply.

29 Felixstowe View Point

In-between Landguard Fort and the Port of Felixstowe is an area known as John Bradfield Viewing Area. Here, you can easily while away a few hours watching the busy container port of Felixstowe – the United Kingdom's busiest container port and ranked thirty-fifth in the world. Watching the comparatively tiny tugs skilfully manoeuvre the massive container ships into the berths is mesmerising – a seemingly David versus Goliath sea battle, with David winning every time.

To the naked eye, in the far distance on the horizon there appears to be one long stretch of land; however, viewed through binoculars or a zoomed camera lens this clarifies that you are looking at two counties divided by a small section of sea – Harwich, Essex, is to the left and on the right is Shotley's marina in Suffolk. If you have time to spare and, depending on the season, you could hop onto a foot ferry from the View Point to make the short journey across the sea to Harwich or Shotley Gate.

A brisk walk along the beach takes you past the imposing Languard Fort and then through into Landguard's Nature Reserve. This is an 81-acre shingle spit

The *Gray Test* tug sailing past the gigantic cranes and container ships at the Port of Felixstowe. These tugs can pull and manoeuvre some of the world's largest ships in and out of their berths.

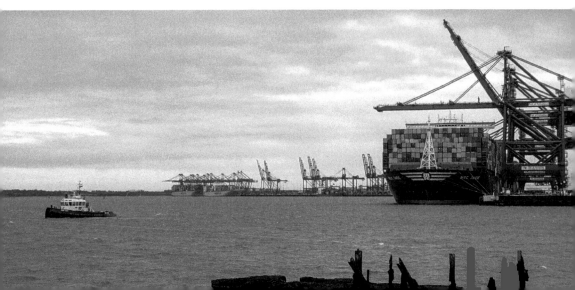

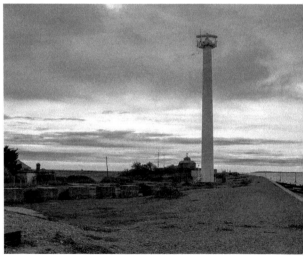

Above: To the right is part of the Georgian and Victorian Landguard Fort. In the centre is the enormous Darell's Battery, built in 1940 during the Second World War when Landguard Fort was the headquarters for the defence of Harwich Haven. To the left, the blue structures are part of the modern Port of Felixstowe.

Right: Landguard's modern-day Radar Tower. To its immediate left, the large doomed concrete building is an elaborate Second World War pillbox. The regular square concrete structures are anti-tank defences put in place in the 1940s.

that is full of rare plants and, depending on the season, migratory birds. The shingle beach is also littered with structures from Britain's Second World War.

Details

Felixstowe is at the end of the A14. After the A14 ends, follow the A154 almost to the centre of town. At the town's traffic lights, turn right and follow signs to Landguard Fort and the View Point. There is free parking at Landguard Fort and at the View Point.

30 Felixstowe

There are two halves to Felixstowe: the frantically busy port on one part, and the traditional seaside town the other, complete with a promenade, amusement arcades and fish and chip shops.

Not quite as genteel as its more upmarket Suffolk neighbours of Aldeburgh and Southwold, nevertheless this seaside town still has a great deal to recommend it. The town's promenade is a pleasure to walk along, with its colourful beach huts and miles of beach.

Several of the east coast's Napoleonic Martello towers were built on Felixstowe's seafront in the early 1800s. In those days this was a deserted, isolated part of the coastline with very few people and houses. By 1871, the census recorded that just over 670 people lived in the parish with approximately ninety living in or around Landguard Fort.

The town continued to increase during the late nineteenth century, particularly after the Empress of Germany and her five children visited in 1891. The *Illustrated London News* of summer 1891 published line drawings of the empress's visit. These drawings demonstrate that Felixstowe was already a very elegant town with splendid Victorian villas, donkey rides along the seafront and children playing on the beaches.

Martello Tower P, refurbished and now used by volunteers of the National Coastwatch providing Felixstowe's 'Eyes along the coast'. A children's park and new luxury town houses now surround the formerly isolated military fort.

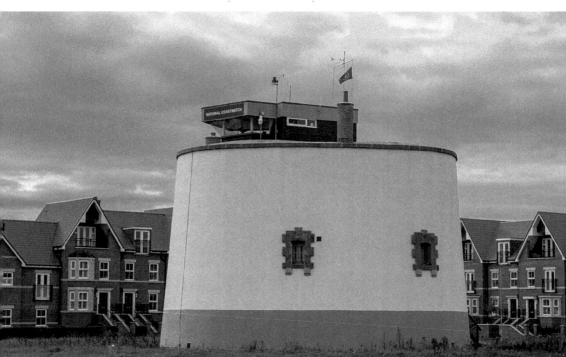

Felixstowe's pier. The buildings at the start of the pier opened in 2017 after the completion of a multimillion-pound schedule of works to demolish the old buildings and rebuild new ones. The pier extends over the sea, but this part of the pier is currently too dangerous to allow public access.

Tragically, Felixstowe was involved in the night of indescribable terror on 31 January/1 February 1953, when severe storms battered the east coast of England and Scotland. Forty-one people lost their lives in Felixstowe during the great floods of that night. Recently, a memorial remembering the tragedy has been built in Langar Road, near to where some of the town's worst flooding and loss of life took place.

A recent change to the seafront has been the redevelopment of the buildings at the start of the pier. The original was built in 1905 and became one of the longest seaside piers in Britain. It was originally used as a landing point by day trippers on paddle steamers to and from London Bridge and Great Yarmouth. In the interwar period it had an electrified tramway running along its length. During the Second World War, the pier was partly demolished and blown up to stop it becoming a landing point for enemy troops. In later years, amusement arcades were built at its entrance; it is these buildings that have been demolished and rebuilt.

Despite the rise of the Great British holiday to far-flung places, Felixstowe still has much to offer today's day trippers, staycation visitors, walkers and local historians.

Details
Felixstowe is at the end of the A14. There is plenty of roadside parking and car parks in the town.

31 Felixstowe Ferry

Not to be confused with its bigger namesake, Felixstowe Ferry is a small coastal hamlet located at the mouth of the River Deben. Part of Suffolk's Area of Outstanding Natural Beauty, the walks around the hamlet and along the coastal path are stunning. Birds are plentiful with herring gulls and great black-backed gulls screeching at the water's edge. Dependent on season (and good luck), you might also catch glimpses of turnstones, redshanks, Temminck's stint, curlews and oystercatchers.

The hamlet enjoys having one of the oldest golf courses in England. During the 1870s the first holes were informally cut into land next to one of Felixstowe Ferry's two Napoleonic Martello fortresses. The first official golf course was built in 1880. For a short period after the course's opening, the guardroom of the Martello tower was used as the course's clubhouse. This fortress is currently unused and derelict.

Like so many of Suffolk's coastal towns and villages, wartime authorities realised both the usefulness and the vulnerability of the hamlet's location. During the First World War, a rifle range was set up on the golf course. In the Second World War, pillboxes and gun emplacements were built as part of the Emergency Coastal Battery Defence Programme.

As you would expect from such a costal location, Felixstowe Ferry also has an active sailing community that is serviced by a very successful and lively sailing club.

Details
Felixstowe Ferry is located at the mouth of the River Deben, a few miles north-east from its much larger namesake Felixstowe.

One of Felixstowe Ferry's two Martello towers, built 1810–12. This one, Tower U, has now been converted into a stylish private residence.

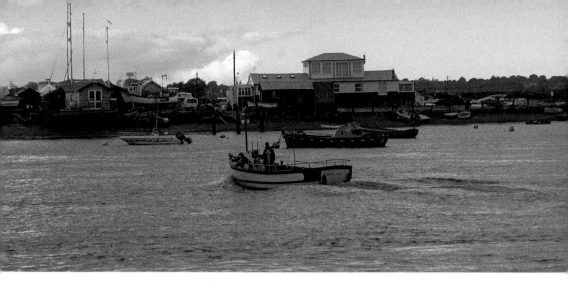

The Deben Ferry carries foot passengers (with or without bicycles) and connects Felixstowe Ferry to Bawdsey Quay on the opposite banks of the river.

32 Waldringfield

The village of Waldringfield is a particularly appealing place to live or visit. Located on the banks of the River Deben in Suffolk's Area of Outstanding Natural Beauty, it can be hard to imagine its Victorian and Edwardian industrial days. Back then, there was the flurry and hubbub of commercial activities taking place in and around the village and river.

From the 1860s until the mid-1890s, coprolite was extracted in large quantities from pits in the village and then shipped by barges to Ipswich. Coprolite is fossilised animal dung and a source of phosphate. In the 1840s, the connection was made between the phosphate in coprolite and the production of artificial fertilizer. By the 1860s, coprolite had been found in great quantity in Waldringfield and shipped to Ipswich for processing. The village's coprolite industry ended in the 1890s.

The village also had another industry and source of employment: that of making cement. Barges loaded with chalk were brought to Waldringfield from the Medway and the chalk mixed with mud from the river to make cement. The industry lasted between the 1870s and 1907. At its peak, there was a large factory with twelve kilns and 100 barges each month travelled between Kent and Waldringfield. The barges brought chalk, coke or coal from the Medway and returned carrying cement. The village's kilns were demolished a few years before the start for the First World War.

A hundred years on and Waldringfield's industrial past has all but been forgotten. Today, in its place, the river and village are now home to people, wildlife and boats.

To the north of the village's pub is a salt marsh. This is an important feeding area for birds, wildfowl, fish and invertebrates. Ducks, geese, waders, gulls and harriers can all be seen. A public footpath runs alongside the salt marsh.

The sun setting over the Deben at Waldringfield.

As well as being a Site of Special Scientific Interest (SSSI), the Deben is also Special Protection Area (SPA) under the Directive on the Conservation of Wild Birds. Over 150 different bird species visit the river and its salt marshes, many of which are on the red or amber lists of Birds of Conservation Concern.

All-year round, waders and wildfowl such as shelduck, oystercatchers, redshanks, bar-tailed godwit and dunlins might be spotted. Migratory wildfowl such as wigeon, teal and the dark-bellied Brent goose visit the river during the winter months. Approximately 30 per cent of the world's population of Brent geese visit the east coast of England, arriving from Siberia and Artic Russia.

Details

The village is a short distance from A12, east of Martlesham Heath. There is a large pay-and-display car park next to the Maybush Inn. Your car park charges will be refunded if you eat in the pub.

33 Woodbridge Tide Mill

The first documented evidence that there was a tide mill on the River Deben at Woodbridge dates from 1170. During the late 1100s, the tithes of the mill were granted to the Austin Canons of nearby Woodbridge Priory. The tide mill continued to be the property of the priory until Henry VIII dissolved England's religious houses in the 1530s and seized its lands – including their tide mill.

The prosperity of the tide mill in these early centuries is unknown, but its importance to Woodbridge Priory was crucial to the priory's wealth. In 1532,

a few years before the priory was permanently closed by the king, there was an investigation ('visitation') by the Bishop of Norwich. *Victoria County History: Suffolk* describes that the visitation found the prior had 'incurred too great expense in making a water-mill' and that 'the priory suffered from penury and want, and that both house and mill were in bad repair'.

The current timber-framed and weather-boarded five-storey tide mill was built in the 1790s and was in regular operation until the 1950s. By the 1960s, it was derelict but privately purchased and restored in the late 1960s or early 1970s. It was restored again in 1982.

Today it is regularly open as a living and working museum owned by the Woodbridge Tide Mill Trust. It is one of the last working tide mills in the country and volunteer millers are often on-site to mill flour ground by its waterwheel.

Right: Woodbridge's busy working quay.

Blow: Woodbridge's tide mill (on the right) and its granary (on the left).

Details

Woodbridge is a few miles north-east of Ipswich, off the A12. The mill is in the town and regularly open between spring and autumn. There are also ad hoc milling days in the winter – check the mill's website for dates and times. There is plenty of public paid car parking in the nearby rail station or in the town centre.

34 Sutton Hoo

Hailed by the British Museum as 'one of the most spectacular and important discoveries in British archaeology', the Anglo-Saxon treasures found in Sutton Hoo need only a slight introduction.

In 1939, the archaeologist Basil Brown was asked to investigate the burial mounds on the land owned by Mrs Edith Pretty. He excavated the largest mound and found within it one of England's most important and breathtaking Anglo-Saxon treasures.

Within the largest mound there was an impression of a 27-metre-long ship with a burial chamber at its centre. This ship was made of oak, but after so many centuries in the earth it had rotted away, leaving behind only its imprint. The burial chamber was full of Byzantine silverware, exquisite gold jewellery, and – Sutton Hoo's most illustrious treasure – an ornate iron Anglo-Saxon helmet. The treasures have been dated to the early seventh century and the burial was that of an Anglo-Saxon king.

There are other burial mounds within the area. The National Trust have estimated that there are approximately eighteen mounds in total. Most of the

Sheep grazing under the winter sky in the Anglo-Saxon royal cemetery, dubbed 'England's Valley of the Kings'.

The largest burial mound – which once contained the Anglo-Saxon ship and its treasures – was rebuilt to its original height in 1992.

other burial mounds have been plundered and robbed over the years, in the centuries before modern archaeology. Only two mounds had remained intact: the largest mound (with its renowned ghostly ship) and a smaller mound containing a young warrior with his horse.

The entire area was a royal cemetery – possibly for the royal family of East Anglia, the Wuffingas, who were descended from the god Woden.

Details
The site at Sutton Hoo is managed by the National Trust and their admission charges apply. There is an excellent visitors' centre and an informative walk around the burial mounds. The British Museum hold the treasures from the burial ship, which can be viewed in London.

35 Bawdsey Coastal Defences

As an island, Britain has always been at the risk of invasion from hostile countries. During various wars, the government have put coastal fortifications into place to stop any potential offensive against Britain. Remnants of these military protections are evident all along the coastline of Britain – particularly on the east coast. One such coastline is the parish of Bawdsey and the area within the village that is known as East Lane. Here there are extensive remains of Britain's Second World War Emergency Coastal Battery Defence Programme.

Concrete pillboxes, a two-storey observation post, gun emplacements and other military structures can all be found at East Lane.

Its entry within the Statutory List of Buildings of Special Architectural or Historic Interest states that the fortifications at Bawdsey are 'one of the most complete 20th century coastal batteries in existence (and 7 out of 116 Emergency Batteries), relating to the rapid enhancement of Britain's coastal defence in the early stages of the Second World War'.

Suffolk contains the relics of the coastal protection for several centuries of wars. The Second World War was not the first time that this part of the British coastline had to be fortified against invasion. Between 1810 and 1812 a series of Martello artillery forts were built all along the east of England's coastline to stop any potential invasion by Napoleon and his army. If you stand on the sea wall by East Lane's car park and turn to the left to face north, you will spot two Martello towers in the distance that are in the neighbouring village of Alderton (Towers Y and Z). The first one is now a comfortable private residence, while the second is slowly rotting away. From the sea wall, and turning to your right, you will spy a third nearby. This is Bawdsey's only surviving tower, Tower W, from an original of three. How much longer this fortress will endure is open to debate as its land is slowly becoming victim to coastal erosion.

There were two other Martello towers in Bawdsey: one at the quay (Tower V) and another, Tower X (now totally vanished), which once stood north of the surviving Bawdsey tower. Martello Tower V was where Bawdsey Manor stands today, but was demolished many years ago; however, it is thought that buried fragments and foundations still exist in the manor's grounds.

Suffolk is full of Martello towers and Second World War coastal defences. Hunting them down is an extremely satisfying way to spend a few days walking the glorious Suffolk coastline, but, sadly, you must be quick before the sea claims more structures.

Second World War Battery Observation Post, built in 1940 in reinforced concrete.

The coastal path between Bawdsey's East Lane and Shingle Street is littered with relics of war. The low building on the left is part of the Second World War defence system. To its right, over the fence into the cliffs and sadly now in the sea, are more structures from the Emergency Coastal Battery Defence Programme. In the mid-distance is the first of Alderton's Napoleonic Martello fortresses (Tower Y), now a desirable residential home. In the distance is Alderton's second Martello tower (Tower Z), which has been abandoned and is fast decaying.

Second World War pillbox slowly being claimed by the sea. This military fortification will not last long before it crumbles into the water.

Details

Bawsdey village is on the B1083, south of Sutton Hoo. East Lane is to the east of the village's centre. There is a small car park and roadside parking by the Second World War defences. Do not attempt to climb or explore the structures as they are all in a fragile state and dangerous to explore. The Martello towers can be sighted from the top of East Lane's sea wall, looking both north and south.

36 Shingle Street

As its name implies, Shingle Street is a shingle beach located in a tiny coastal hamlet. It is between Bawdsey to the south and Orford to the north, and lies at the mouth of Orford Ness. Most of the hamlet consists of desirable holiday cottages that are always fully let in summer but often empty in winter, with the beach then an empty and deserted place.

Like so many other coastal villages in Suffolk, Shingle Street also has a chequered wartime past. During the Second World War, in June 1940, the hamlet was totally evacuated, with villagers given three days' notice as a German invasion seemed imminent. For many years after the war, there were numerous rumours (now disproved) that there were countless bodies of dead German troops washed up on Shingle Street's beach.

The hamlet also has one of Suffolk's surviving Martello towers (Tower AA) built to stop any potential invasion by Napoleon. Shingle Street's other Martello fortress (Tower BB) has been lost.

The hamlet once had an important HM Coastguard Rescue Station, which was decommissioned in 2011 and sold at auction in 2015 for £247,500. For many decades coastguards were housed in the accompanying Victorian purpose-built white coastguard cottages.

Tragically, one of Suffolk's worst coastal disasters took place in May 1914, involving the coastguard crew from Shingle Street. The coastguards were returning from Aldeburgh with their pay and stores, when their boat capsized during a gale after it was accidently driven onto a sandbank. The accident happened when they were very near the safety of their own station at Shingle Street. Newspaper reports of the time state that other coastguard men on the beach at Shingle Street saw the boat capsize, but despite launching another boat, were powerless to help. Five out of seven men drowned. Horrifically, wives and children of the doomed men watched from the shore as their men died in the waters. Eight children were left fatherless that night. A sad and stark reminder of the cost in the terms of human life for those employed by the coastguard service.

Immediately after the disaster, a local newspaper described the hamlet thus:

[A] desolate hamlet on the mainland surround by marshes and shingles. It consists of a coastguard station, an inn and a few bungalows, a place seldom reached by visitors. So dangerous is the river bar owing to the continually shifting shingle that pilots are needed for yachts and small vessels. The sea forms shingly islets as it rushes into the river.

Today, Shingle Street seems much the same as it must have been at the time of the accident (except now without the hamlet's only pub). Now, like then, the beach and sea can be an oasis of peaceful calm with people enjoying leisure pursuits, but it is also a dangerous and powerful force of nature.

Details

From the A12, take the exit east for Sutton Hoo (A1152) then follow signs for Shingle Street. There is a small, but busy, car park at Shingle Street.

Right: Storm clouds over the former HM Coastguard Rescue Station and coastguard cottages. Modern film-makers like the wild beauty of Shingle Street; recently the village featured in the BBC adaption of Ian McEwan's novel *A Child in Time*, starring Benedict Cumberbatch. It is hard to determine who was the star of the programme: Shingle Street or its actors.

Below: Fishermen camping on the beach at Shingle Street. The coastguard cottages are on the right in the distance.

37 Orford

Henry II built Orford Castle between 1165 and 1173 for the staggering sum of £1,413 to thwart the activities of the Earl of Norfolk. Worryingly for the king, Hugh Bigod, the Earl of Norfolk, held tremendous power within East Anglia and was increasingly seen as a threat to Henry's royal authority. Principally to curtail the activities of the earl, the king built his royal stronghold and fortress at Orford.

The castle was built from four different types of rock, with locally collected septaria being the major building material. The fine architectural detail was made from Normandy's Caen stone. Northamptonshire limestone (Barnack stone) was used for facing blocks and the interior of the castle used Coralline Crag rock.

In 1336, the Duke of Suffolk, Robert of Ufford, purchased Orford Castle from Edward III. It stayed in private hands until 1928 when it was presented to the nation. It has been the responsibility of English Heritage since 1984.

By the twelfth century, Orford was a busy and successful trading seaport. From the thirteenth century until 1886 it held borough status, granted by two charters from Henry III in 1256. From the late thirteenth century/early fourteenth century Orford sent two men to represent the borough in Parliament in London, a situation that remained until 1832. This was the year that the Great Reform Act addressed the issues of so-called 'rotten boroughs' such as Orford. Orford borough became one of the fifty-six boroughs in England who lost their franchises in the 1830s.

The town's heyday was certainly the medieval and Tudor period. During these years, the town held weekly Monday markets and a yearly fair on St Bartholomew's feast day in August. An Elizabethan charter from 1579 gave the town the right to be a free borough, the right to hold property and the right to hold courts.

By the eighteenth century, the town was fast in decline. Daniel Defoe, in his 1720s travel book, *A Tour Thro' the Whole Island of Great Britain*:

> Orford was once a good town, but is decay'd, and as it stands on the land-side of the river, the sea daily throws up more land to it, and falls off itself from it, as if it was resolved to disown the place, and that it should be a sea port no longer.

Twenty years after Defoe's book, the writer Samuel Richardson updated it in a new 1742 edition. Richardson wrote of Orford

> The sea has so much withdrawn itself from this town, that it is robbed of its chief advantage, and deserves not the name of a harbour. The town is mean, and no one contends for an interest in it, but such as want to themselves a merit in the choice of the two Members which it returns to Parliament.

Defoe and Richardson were perhaps harsh in their judgement of the town. A hundred years after them, a line engraving made by Robert Brandard (after a

drawing by Joseph Mallord William Turner) demonstrates that the harbour was still very active in the 1820s.

Today, Orford is a small but busy and popular town for locals and tourists alike. There are only 650 people on the electoral roll, but with a majestic castle and church, picture-book cottages, first-rate eating places, good walks and ample boating pursuits, there is plenty to do.

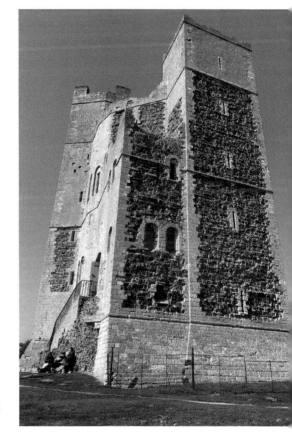

Right: This was once a huge castle with outer fortifications and a curtain wall containing flanking towers with a fortified gatehouse. Today, all that remains of Henry II's great castle in Orford is its magnificent keep.

Below: The view of the town from the top of the castle's keep. In the distance is Orford Ness and the lighthouse (centre on the horizon).

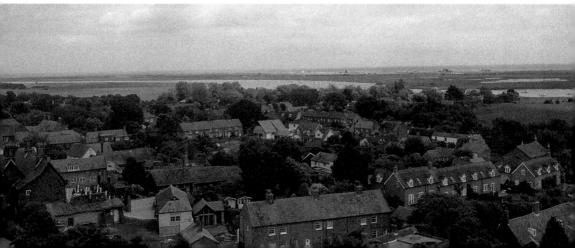

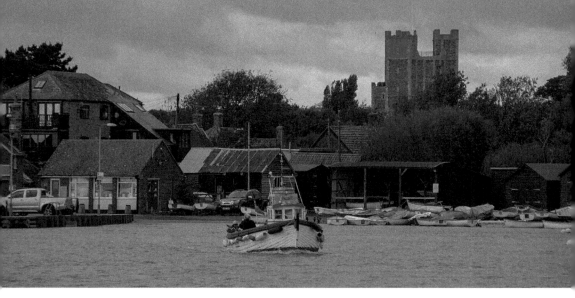

Orford Quay with the castle's keep in the distance. This waterside scene has been photographed, sketched and painted many times.

Details

Orford is on the east coast of Suffolk, south of Aldeburgh. There is limited parking in the town centre and roadside. Alternatively, there is a large pay-and-display car park at the end of Quay Street – almost at the quayside. English Heritage admission charges apply at Orford Castle.

38 Orford Ness

This spit of land contains the most startling and disquieting coastal landscape of anywhere in Suffolk, and indeed anywhere in the entire east of England. At first sight, it is partly a bountiful nature reserve set among grazing and reed marshes, with coastal brackish water lagoons and partly an uninhabited shingle heath and beach slowly being reclaimed by the North Sea. But scattered all over Orford Ness are the decaying and crumbling buildings that are the living testament to Britain's part in two world wars and the later development of atomic weapons.

As you approach the Ness from the comfort of the National Trust's own water ferries (who bought Orford Ness in 1993), the first part of the spit is reclaimed grazing marshland. However, even this attractive area bears the traces of war. During the First World War, this location contained an airfield that was home to the Armament Experimental Flight of the Central Flying School, where pioneering aviation research work was undertaken. By the end of the First World War over 600 personnel – many from the Royal Flying Corps – lived and worked at the airfield site at Orford Ness. Some of their buildings remain today.

As the twentieth century progressed, more military buildings were built in the 1940s and 1950s, and were only abandoned by the Ministry of Defence in the 1980s. Many of these have now been converted to provide accommodation and visitor centres for modern-day visitors and researchers.

Most dramatically on the Ness's horizon are the gigantic and substantial buildings of the Atomic Weapons Research Establishment (AWRE). Nicknamed the 'pergodas', the buildings were purpose-built colossal laboratories used for environmentally testing the components of atomic weapons. The work carried out by the AWRE was top secret and most of their research is still classified information. The AWRE left Orford Ness in 1971 but the traces of Britain's involvement in the development of the atomic bomb has left indelible marks on Orford Ness's landscape.

To complete Orford Ness's military past is the Cobra Mist site. Formerly top secret, the site housed a joint Anglo-American radar project that was set up during the height of the Cold War in the 1960s. Abandoned in 1973, the site now houses the BBC's world service radio transmitters.

The landscape of Orford Ness is multifaceted. Over a mile from the National Trust's jetty is its shingle beach. Here, scattered among twentieth-century military buildings, is the 30-metre-high lighthouse that was privately built in 1792. Trinity House took over the lighthouse in 1837. In 1965, the lighthouse keepers were removed as the light was automated the previous year. In June 2013 it was decommissioned because of the encroaching sea. The Orfordness Lighthouse Trust now own the lighthouse.

Originally built some distance from the edge of the coast, the sea is now mere feet away from the lighthouse. Coastal erosion means that, despite the trust's rigorous and extensive endeavours each winter, it will not be too many years before this magnificent building will crumble and disappear under the waves.

Even on the shingle beach there are signs of war, this time in the simple signage advising you not to stray from the pathways nor pick up unknown objects. On my family's visit to the Ness, the National Trust warden warned us that over 10,000 pieces of military ordnance were removed or exploded when they took over the land, and that they cannot guarantee that all the ordnance has gone. It is a stark warning that we heeded.

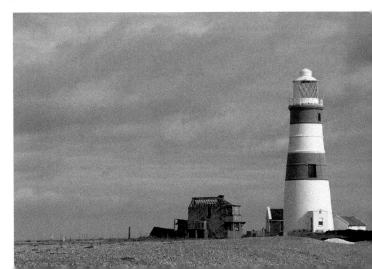

Orford Ness lighthouse. To its left is the mid-nineteenth-century HM Coastguard Lookout (now in ruins).

Slowly, however, the land is restoring itself back and away from the undertones of war. Depending on the season, brown hares are plentiful; sheep and cattle graze peacefully on the marshes; various species of birds can be spotted; and wild flowers such as scarlet pimpernels, yellow horned poppies and sea peas grow within the shingle. The past, present and future is all around the living landscape of Orford Ness.

Details

Location and parking details are the same as the previous entry for Orford. The National Trust own Orford Ness and it is only accessibly by boat. It is free to visit for members, but there is a charge for using the ferry – buy tickets from the National

Left: Built in the 1950s, these are the first atomic weapons test cells built by the AWRE on Orford Ness. August bank holiday in 1956 saw the first major test of an atomic weapon on Orford Ness.

Below: Sheep graze on the reclaimed grazing marsh, which was once the site of a First World War airfield. In the background are the pergodas – test laboratories for atomic weapons.

Trust's hut on the quay before boarding the boat. The journey from Orford's quay to the Ness's jetty is mere minutes. The ferry is seasonal, so check the National Trust's website for dates and times. The National Trust do not own the lighthouse and you can view the outside from the beach. The charitable organisation who owns it have various open days throughout the year – check their website for details.

39 Havergate Island

Located in the Alde-Ore Estuary, nestled between Suffolk's mainland to the north and the spit of Orford Ness to the south, Havergate Island is Suffolk's only island. The island is a small one, at 2 miles long and 0.5 miles at its widest point. It is comprised of salt marshes with saline lagoons and shingle.

The island was privately owned at the beginning of the twentieth century, and in 1923 a gravel company unsuccessfully tried to extract shingle from it. In the late 1940s, breeding avocets were discovered on the island – the first seen in Britain for over 100 years. This prompted the Royal Society for the Protection of Birds (RSPB) to buy the entire island in 1948.

Two geese fly over the lagoons at Havergate Island. Orford Castle can be seen in the distance on the mainland.

One of Havergate's brown hares sleepily sunbathes camouflaged in the thick gorse in the early spring sunshine.

Havergate Island is now designated a national nature reserve, a Site of Special Scientific Interest (SSSI), a Special Area of Conservation (SAC), a Special Protection Area (SPA) and a Ramsar site. More recently, the RSPB have implemented a rigorous programme of work to provide the optimum environment for the island's wildlife. Effective modern sluices have replaced old ones, and some of the small islands and lagoons have been redesigned. The RSPB have also installed several hides throughout the island, and an ingenious composting toilet.

Birds that can be seen here include the avocet (adopted by the RSPB as their emblem in the 1970s), ducks, common terns, pintails, spoonbills and wading birds. Havergate is also famous for its population of brown hares. These can often be spotted in the gorse-covered shingle located by the warden's and volunteers' huts at the south-west end of the island.

Although the island has many visitors during the spring and summer months, it never seems overcrowded and is full of like-minded people eager to help the novice twitcher (such as myself) spot and identify the island's many birds. It really is an outstanding place to spend a few hours with nature.

Details

The island is only accessible by RSPB's pre-booked boat trips. Visit their website to find out cost and times. The RSPB also run regular event days throughout the year, such as 'Havergate Hares' in March and April. Park at the public car park at Orford's Quay and join the boat at Orford's quayside.

North-East

40 Framlingham Castle

Now largely in ruins, Framlingham Castle, with its substantial buildings and grounds, is an intriguing monument from many other ages. Its history has been wide and a varied. A Norman castle, a medieval fortress, a queen-in-waiting's refuge, a Tudor gaol holding Catholic priests, a seventeenth-century village poorhouse, and now a much-loved tourist attraction.

It was built early in the twelfth century and was the seat of the dukes of Norfolk for many centuries. However, as a passionate Tudor social historian, its appeal to me is that of its role during the Tudor era.

In the 1550s, Framlingham Castle became the centre of one of the most important turning points in English history: the acceptance that an English princess

From high on the castle's ramparts, the Red House looks like a doll's house inside a magnificent castle. It was built in 1664 as the town's poorhouse and was in operation as a workhouse until 1839 when the inmates were transferred to Wickham Market. The building then had a variety of uses including a school and parish hall.

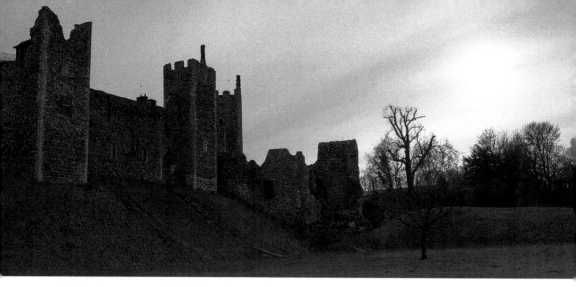

England's return to Catholicism during the reign of Mary I was short but bloody. Her successor, Elizabeth I, reverted the country back to Protestantism, whose reign was also marked by religious bloodshed. During Elizabeth's rule (1558–1603) one of the castle's towers was used to hold forty priests who were still practising the then illegal Catholic faith.

could become a queen in her own right. It was at the castle that Henry VIII's daughter, Mary, was proclaimed queen. Notwithstanding the Empress Maud (who was never crowned Queen of England), Mary I was England's first queen regnant.

The Protestant boy king Edward VI named in his *Devise for the Succession* that upon his death England's throne would go to his cousin, the tragic Protestant pawn Lady Jane Grey. This was an attempt to stop England returning to the Catholic faith under his half-sister, Mary. Edward VI died on 6 July 1553. Mary, the legitimate heir to England's throne, fled to East Anglia and eventually to Framlingham Castle where she rallied troops loyal to her.

Within days she had raised an army consisting of 20,000 men at Framlingham. Her opponents crumbled, Lady Jane Grey was captured and imprisoned, and Mary was declared queen while still at Framlingham Castle.

Framlingham Castle was eyewitness to some of the most important events of Tudor history. More recently, it has become the unlikely star of Ed Sheeran's 2017 triple-platinum song 'Castle on the Hill'. Sheeran has stated that his song is his 'love letter to Suffolk' and it articulates his formative years growing up in the shadows of Framlingham Castle. The castle featured in Sheeran's official video, which, by March 2018, had been viewed over 305 million times. Sheeran's current home is in a small hamlet near to Framlingham.

From being the place where a Tudor princess was declared the Queen of England, to a popstar reminiscing about his teenage years, Framlingham Castle's past is never too far from its present.

Details

Framlingham Castle is located to the north of the A12. If arriving from the south, exit the A12 at Wickham Market and then follow signposts to Framlingham. There is plenty of parking outside the castle. English Heritage manages the castle and their entrance fee applies. Check their website for seasonal opening times.

41 Snape Maltings

Suffolk is a truly remarkable county with stunning coastline, heathland areas and medieval wool towns. To choose just one place as an overall gem should be a hard decision; however, for me that choice is made easier by the existence of Snape Maltings. Over the many years that I have lived in the East of England, the Maltings is the one place in Suffolk that I revisit time and time again.

Each new season brings different highlights, although the harsh winter months is my favourite season: the hordes of summer visitors have vanished and the area beds itself down for winter. The Maltings is just begging to be explored, with its riverside footpaths, shops, modern sculptures, industrial architecture and, of course, the world-class concert hall founded by Benjamin Britten and Peter Pears.

If you're feeling energetic you can walk the 6 miles from the Maltings along the footpath now called Sailors' Path to Aldeburgh. For those, such as me, who are less energetic, then there is a mile-round circuit walk along the path to the village of Snape. The walk along the River Alde is a peaceful and calming experience as it winds through Snape Marshes and Snape Warren. As you stroll, cast your mind back to previous centuries and the comings and goings of smugglers that were once very active all along this part of Suffolk.

If the picturesque walks are not enough, then there is always the shopping. I belong to that rare breed of women who does not enjoy shopping, but Snape Maltings is my exception and, to my husband's absolute horror, I can spend hours browsing the varied and wondrous shops within the Maltings complex.

If you are lucky, as you walk around the complex you might hear concerts or musicians practising in Benjamin Britten's mesmerising concert hall. I photographed the pictures of Snape Maltings for this book very early one gorgeous October morning, just as the sun was rising over the mist. As I was walking through the deserted complex the sounds of talented musicians practising their craft wafted

Autumn sunrise at Snape Maltings.

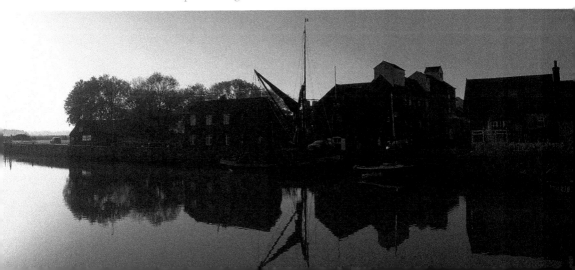

over the reeds and marshes, creating a delicate and spiritual atmosphere. No wonder the man who was arguably Britain's greatest composer was inspired by Suffolk and used the former industrial maltings as his concert hall.

Modern art also has its place in the complex. Over the years there has been a variety of modern art and sculptures placed throughout the Maltings – some in the inhabited parts and others in the derelict areas. Some have been very interesting to view, while others have been extremely peculiar and bizarre. Although, even the weird and wonderful exhibitions provide an opportunity to see derelict areas that are not normally accessible to the public.

If all of the above is not enough, then there's the splendid Victorian industrial architecture of the maltings complex to amble around, admire and appreciate. What's not to like? It has it all: music, modern art, Victorian industrial architecture, shopping, historic riverside walks; marshes, a nature reserve, reeds and wet woodland teeming with wildlife, birds and insects; and, of course, delicious food and beverages. Snape Maltings is, unquestionably, my number one most cherished Suffolk gem.

Details

Snape Maltings is on the B1069 a few miles east of the A12. There is a large free car park within the complex.

The River Alde and Snape Marshes.

Barbara Hepworth's 1970 unfinished sculpture *The Family of Man* outside Benjamin Britten's concert hall.

42 Leiston Abbey

The abbey was founded in 1182 at Minsmere marshes during the reign of Henry II. The abbey was rebuilt in its current location at Leiston in 1363 using some of the original building material taken from Minsmere. This second abbey was larger than the first and contained a church and several chapels. It was home to Augustinian canons who followed the Premonstratensian rites. Nicknamed the White Canons because of the colour of their habits, the canons were not monks but instead ordained priests whose work also included duties within local parishes.

Leiston was one of thirty-three English abbeys and priories founded by the White Canons between the order's foundation in 1121 and their disbandment in England during Henry VIII's Dissolution of the Monasteries. Leiston Abbey was dissolved in August 1536 when Suffolk's commissioners for the king arrived at the site. They drew up an inventory of the items and possessions within the abbey, including cows in the abbey's home farm. They found the inventory to be worth only £42 16s 3d, despite the abbey's annual value being £181 17s 1¾d. The last abbot, George Carleton, received a pension of £20 but the other canons were expelled – destitute – from the abbey. The following year, Henry VIII granted the abbey and its land to his brother-in-law Charles Brandon, Duke of Suffolk.

Over the subsequent centuries, stone from the former abbey was used as building material for nearby houses. A farmhouse and farm buildings were built in its ruins and the canon's church was used as a barn. In 1918, the Lady Chapel was restored by the site's owner and used for religious retreats. Today, a charity named Pro Corda (an international Chamber Music Academy) owns the abbey. The restored parts of the abbey are used 'to provide for and conduct the education of young persons and others in the whole art, philosophy and theory of music, particularly chamber music'. English Heritage maintain the abbey today.

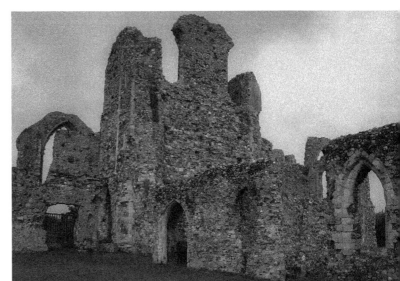

With the music of Pro Corda's pupils occasionally wafting eerily through the stonework of the ancient site, visiting the ruined abbey can be a strange ethereal experience.

Details

The abbey is situated a short way from the B1122 and a couple of miles south of the town of Theberton. There is a small car park. Parts of the site are private, but the grounds and abbey are open to the public during daylight hours.

43 Aldeburgh

This enchanting seaside town brings back so many memories for me. When my son was growing up a trip to Aldeburgh was a regular occurrence. A day at the seaside with a lunch or supper of fish and chips on the shingle beach and a browse in the second-hand bookshops was just heaven. Something for everyone.

In fact, the chips at one of the two chip shops within the town is an absolute must. Chips from Aldeburgh are often quoted as being among Britain's finest. As I would risk incurring the wrath of many people, I will not tell you the optimum time to join the inevitable queue at the chippie and which queue out of the two chippies moves the fastest. All I will say is make sure you are towards the beginning of the line! Once the queues start – in good British fashion – everyone joins them.

Of course, Aldeburgh is enticing for many other highlights, not just its chips. In modern times, the town's legendary sons include the hugely talented British composer Sir Benjamin Britten and his partner, the tenor Peter Pears.

There are plenty of reminders of their partnership throughout the town. The Red House, where they moved to in 1957 from the seafront is now open to the public. Maggi Hambling's controversial stainless steel sculpture *Scallop* on the beach, created in tribute to Britten's opera set in Aldeburgh – *Peter Grimes* – is another reminder. People are positively encouraged to climb and sit on *Scallop* and contemplate the sea – a pastime my son has much enjoyed.

In June 2013, the Aldeburgh Festival staged the opera for a spine-tingling performance on the town's seafront. Whenever I visit Aldeburgh, the haunting sounds of the 'Prologue: On the Beach to Peter Grimes' is not far from my mind's ear.

Aldeburgh is a seaside town with something for everyone. As my son is now a teenager with different hobbies our days to the beach are not as often as they once were. But when we do go, he still wants to skim stones into the sea, play boules by the seafront and sail boats in the town's boat pond.

On reflection, for my own personal memories of happy days on the beach, and the evocative sounds of *Peter Grimes*, Aldeburgh must be my second most cherished Suffolk gem.

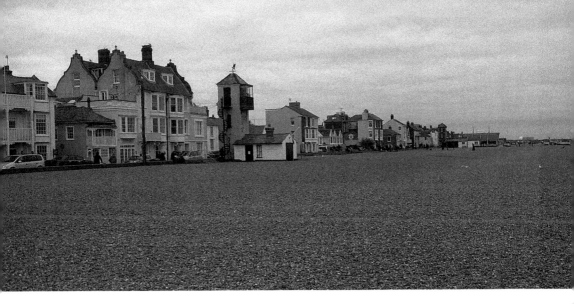

Above: Aldeburgh's shingle beach. In the centre of this photograph is the Beach Lookout. Originally built in the nineteenth century, today the Lookout is now a venue and inspiration for artists.

Right: I recall one New Year's Day not quite correctly timing the mammoth queue and waiting for over an hour in an ever-snaking line of people and their dogs. The chips were worth every single second we patiently waited! This was just the front part of the queue...

Details
Aldeburgh is a few miles from the A12 – follow the A1094 eastwards. There is limited roadside parking in the town centre.

44 Thorpeness

Even today, a hundred years after it was first built, the holiday village of Thorpeness still has the aura of a fairy tale or an illustration from a children's book.

In 1908, barrister and playwright Glencairn Stuart Ogilvie inherited a large Suffolk estate after the death of his mother, Margaret. His Scottish father,

Alexander Ogilvie, who died in 1886, made a fortune as a railway engineer and a contractor of public works. In the 1850s, the Ogilvies moved to a house in Aldringham and renamed it Sizehall Hall. Over time, first Alexander and then his wife, Margaret, increased the estate to 6,000 acres by buying land around their home. Part of the Ogilvie's estate included the small fishing hamlet that eventually became known as Thorpeness.

Two years after his mother's death, Ogilvie decided to build a graceful and luxurious holiday village that he named Thorpeness. The village was filled with weatherboard cottages, mock-Tudor houses, tennis courts, a swimming pool and a golf course. All built for the purposes of the leisure of the Ogilvie family, their friends and their associates. The houses and village stayed in the Ogilvie family's hands until the 1970s when death duties forced the sale of some of the village's unique buildings.

There is much to be marvelled at within the village. Highlights include the House in the Clouds. Built as a water tower, Ogilvie disguised its structure by giving the building the appearance of a cottage 70 feet high in the sky. The water tank was removed in the 1970s and the former water tower is now a luxury holiday home. The village also boasts an illusionary medieval gatehouse with arrow loops (which also hides a water tower at the top) and an artificial boating lake inspired by *Peter Pan*.

Some of the holiday cottages were built between 1911 and 1914, and even then were fully equipped with all mod-cons, including furniture, running water and gas. Other buildings, such the House in the Clouds, Westbar and the almshouses came later – between the two world wars.

To this day, Ogilvie's unique holiday resort remains a cohesive and aesthetically pleasing example of fine architectural design and planning. In the summer the village is packed full of holidaymakers and day trippers, all enjoying Ogilvie's unique and progressive concept.

Details
Thorpeness is to the north of Aldeburgh. It can be reached on the coastal road from Aldeburgh or the inland route on the B1353 to the east of Aldringham. There are car parks in the village.

Westbar, built in 1928–29. Pevsner describes the tower and this part of the village as 'like an overgrown toy fort with corner turrets and arrow loops. The houses are the most determinedly faux medieval of the whole village, wilfully picturesque'.

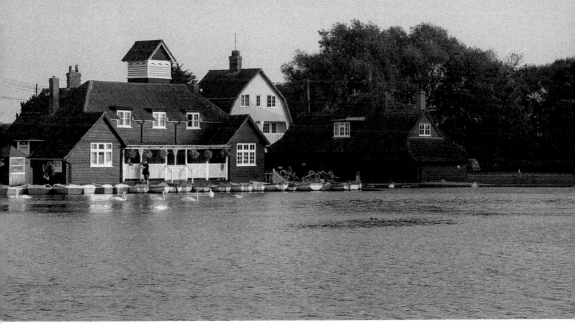

The mere. This artificial lake was inspired by the magical book *Peter Pan*, written by one of Ogilvie's friends, J. M. Barrie. The entire lake and land covers 60 acres (40 acres of which are water) and has islands and secret coves named after characters in the book.

45 Sizewell

Walking the coastline at Sizewell Beach can be a perplexing experience. With two nuclear power stations visible from the beach, its immediate past and current present is glaringly obvious. However, the beach at Sizewell has another claim to fame, aside from its nuclear power stations. In the past the coastline around the village was renowned for the smuggling of contraband goods such as alcohol, tea and dry goods. Most notorious of all the Suffolk smugglers was a band of up to 100 men nicknamed the Hadleigh Gang.

They operated during the eighteenth century and regularly clashed with the authorities. Their operations were so vast that they regularly brought in contraband around the coastline of Sizewell and inland to Hadleigh where they had their own stores. In the 1730s after an ambush when a dragoon was murdered, several of the gang were tried at the assizes and subsequently hanged or transported.

Smuggling was a problem around Sizewell for many decades. Late eighteenth-century newspapers reported several cases of smugglers clashing with militaria and dragoons around Sizewell. This clash was reported by the *Derby Mercury* in December 1781 and the number of wagons and carts involved was enormous.

In the night of 28th Ult. [28th November], a Mr Bell, supervisor, with four Excise Officers, and twenty of the Suffolk Militia, all armed, having seized

about thirty wagons and carts laden with run goods, consisting chiefly of spirits and tea, at a place called Sizewell Gap, near Saxmundham, were attacked by a gang of smugglers on horseback, who came to rescue the goods, soon after seizure had been made; and that after the smugglers had beat the officers so long as they pleased, and broke the Supervisor's arm in two places, they went off with the whole cargo. It is reported that the Excise Officers ordered the soldiers to fire, but they refused, and begged for mercy.

This report from the *Ipswich Journal* in February 1788 demonstrates that troops regularly had to be deployed to protect cargo seized from the smugglers: 'On Tuesday two waggon loads of foreign brandy, lately seized by the vigilance of the revenue officers, near Sizewell Gap, were escorted by a party of dragoons, to the excise office in this town [Ipswich].'

Today Sizewell Beach is an enjoyable beach to walk on – even if you are walking in the shadow of the vast nuclear power stations. If you stop to have a cup of tea at the beach's café, take some time to reflect on the battles between smugglers and excise men at Sizewell.

Above: Fishing boats on the beach with Sizewell A and Sizewell B nuclear power stations in the background. Sizewell A is in the process of being decommissioned. Sizewell B is the UK's only pressurised water reactor.

Left: Sizewell A's redundant offshore rigs. Now only kittiwake gulls and other seabirds visit the structure.

Details

The beach at Sizewell is a couple of miles east of Leiston, which itself is 5 miles east of Saxmundham on the A12. There is a public car park at the beach. Sizewell B has a visitors' centre – check EDF Energy's website for opening times.

46 Minsmere

The RSPB have several nature sanctuaries in Suffolk. One of its most popular and best known is the reserve at Minsmere in Suffolk's Coast & Heath Area of Outstanding Natural Beauty.

The reserve had its beginnings during the Second World War when parts of the coastline of East Anglia was flooded as a defensive measure against invasion. Sluices were opened at Minsmere allowing the existing grazing marshes and ditches to flood. The flooded meadows and marshes provided an ideal environment for meres, marshes and reedbeds to flourish.

Shortly after the war, in 1947, the Royal Society for the Protection of Birds (RSPB) leased the land from its owner and started the reserve. The society finally purchased the land in 1977. Today, after more purchasing more farmland and grazing marsh next to the original reserve, the site covers 1,000 hectares. The reserve consists of sand dunes, saltwater lagoons, shingle beach, reedbeds, lowland wet grassland and lowland heath. It has been designated a Site of Special Scientific Interest (SSSI), a Special Area of Conservation (SAC), a Special Protection Area (SPA) and a Ramsar site.

With its many different habitats, numerous species flourish in abundance with more than 5,000 different species identified. This includes 340 bird species, 1,000 species of moths and butterflies, and 1,500 species of fungus.

The Scrape, an artificial area of shallow water with mud islands, was innovatively constructed in the 1960s by the reserve's then warden and is now home to thousands of birds. Wildfowl such as mallard, shelduck, wigeon, gadwall and teal are often seen on the Scrape and Levels.

In its woodland area the trees are thronged with various birds, such as woodpeckers, jays, treecreepers and tits. Sometimes present at various locations and during various seasons are owls, nightingales, terns, oystercatchers, lapwings, bitterns, marsh harriers and, if you are lucky, the reserve's avocets.

The site also produces a unique environment suitable for insects, plants and fungi to flourish within the beach's shingle and reed beds, wetlands, and marshes. Mammals are often present too, such as a herd of red deer, otters, water voles, water shrews, brown hares, weasels, bats seals and harbour porpoises (though these are sometimes seemingly invisible).

The reserve is so well respected that the BBC's *Springwatch* programme had a three-year relationship with it. Cameras, film crew and wildlife experts set up camp in the sanctuary each year to film the comings and goings of its wildlife population.

Details

RSPB Minsmere is located between Dunwich (to the north) and Sizewell (to the south). Follow the brown tourist signs from Westleton to the reserve. It is owned and run by the RSPB and their entrance fees apply. There is a large car park and a café. Check the RSPB's website for opening times and species likely to be spotted at any given season. Bring binoculars and/or cameras as there are seven hides located throughout the reserve to set up camp and birdwatch.

Left: In 2014, the BBC *Springwatch* film crew left their mark on the ceiling of the brilliantly named Eel's Foot pub in nearby Eastbridge.

Below: The Scrape is full of wildfowl in late autumn.

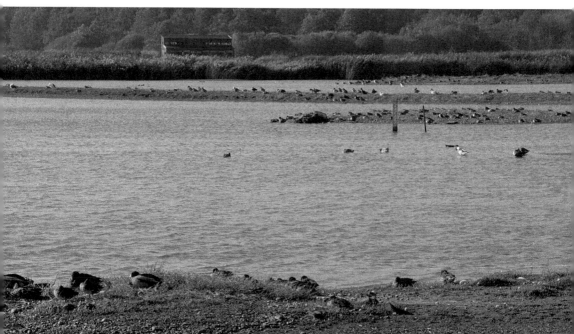

47 Dunwich

There are very few man-made events that have left such a massive and visible scar on the landscape of England than Henry VIII's Dissolution of the Monasteries in the 1530s. Once the Tudor king decided to rid himself of the pope's power in England, religious houses were forcibly closed all over the country. And if Henry VIII's destruction was not enough, then his son, the Protestant boy king Edward VI, followed through his father's policies in the 1540s by wiping out any remaining religious houses.

Henry VIII's destruction of what was arguably one of the first social care and welfare systems in England is all too apparent at Dunwich within the ruins of Greyfriars. Until the friary was seized by the Bishop of Dover in 1538, it had been a very successful Franciscan monastery from the time of its establishment in the 1250s. Its size and grandeur can only be imagined as you wander through its ruins. Where once monks tended the land and went about their daily business, now there are only animals grazing and munching within the friary's ruins.

However, not all of Dunwich's misfortunes were entirely due to a raging, vengeful sixteenth-century king. The real villain in the story of Dunwich has been the combined forces of sea and Mother Nature. Much of medieval Dunwich has been reclaimed by the sea. Dunwich once housed at least eight medieval churches and chapels, but one by one the sea has stolen the buildings. With many of Dunwich's churches lost in the early medieval period, a further natural catastrophe in the form of a storm caused the loss of most of the town in January 1362.

The town has survived, though, but with far fewer people. Because of its former medieval size, combined with its wealth and power, it retained the right to send two members to Parliament until the Reform Act of 1832. Dunwich was another of Suffolk's infamous 'Rotten Boroughs' – rotten because the size of its tiny post-medieval electorate did not match the privilege and right to send two men to Parliament.

Abandoned because of its size in 1750, the sea took All Saints' Church as its final victim in the first quarter of the twentieth century. It is said that sometimes bones from its graveyard break through from the cliff's edge and can be seen poking through the cliff. Hopefully, All Saints' will be one of the sea's final

The ruins of Greyfriars.

Southwold from Dunwich Heath. Somewhere in the sea between the heath and Southwold lies the lost town known as Britain's Atlantis.

victims, although it is thought that even the ruins of Greyfriars will eventually fall into the clutches of the savage ocean.

Dunwich can be an eerie place to walk around. Naturally beautiful and with the incredible heritage of a once great medieval but now vanished town. It is not surprising there is a legend that sometimes when you stand on the beach at Dunwich you will hear the tolling of church bells from one of the town's lost churches, hidden deep within the ocean.

Details
Dunwich is located a short distance to the east of Westleton. There is a large National Trust car park (free to members) on Dunwich Heath. A mile to the north of the National Trust site is the tiny town, the ruins of Greyfriars and a large free public car park on the seafront.

48 Blythburgh

One of the grandest churches within Suffolk is that of the Holy Trinity in the coastal parish of Blythburgh. It rises majestically over the reeds and marshes of the Blyth estuary and is often nicknamed the Cathedral of the Marshes.

Blythburgh was already a successful, prosperous and large market town (for the period) with a church by the time it was documented within Domesday

in 1086. Various evidence suggests that a church was located within Blythburgh centuries before the Norman Conquest. An eighth-century Anglo-Saxon writing tablet made of whale bone with copper-alloy rivets and a runic inscription was found in Blythburgh. This implies that Christianity had arrived to this part of Suffolk very early. The tablet is now in the care of the British Museum.

The current parish church was rebuilt by the Augustian priory in the village in 1412. Thus, Blythburgh's awe-inspiring church was not built on the wealth of Suffolk's wool trade but rather on the wealth of a medieval monastery.

Pevsner comments that the town was already in decline by the time of the church's rebuilding. Furthermore, despite substantial bequests made to the church throughout the fifteenth and sixteenth centuries, the town and its church continued to wane from the 1600s onwards.

Progress and industrialisation were brought to the town with the arrival of the Blyth Navigation. This canal opened in 1761 but was formally abandoned in the 1930s. In 1879, Southwold Railway opened a 3-foot narrow gauge line between Southwold and Halesworth, and a station with two goods sheds was built in Blythburgh; however, the line was short-lived and closed in 1929.

The Blythburgh of today is tiny. Despite its size, however, it is bisected by the A12 – a major road. The A12 also has a bridge that crosses the River Blythe with views across the river. Very often, people only see Blythburgh and its river from the misleading vista of car window. Yet we cannot blame modern road planners for building the A12 through the village. They were merely following an existing turnpike road built in 1785, which ran straight through the village.

Old wooden groynes in the River Blyth with the 'Cathedral of the Marshes' rising magnificently in the distance.

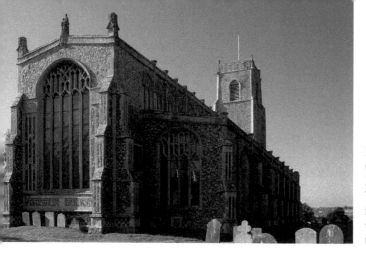

Holy Trinity Church and the chancel's east window. Medieval craftsman Thomas Aldryche's frieze of flushwork initials below the window is superb, with God to the top and centre.

Despite the A12 and the noise of its traffic, Blythburgh is an inviting village with breathtaking riverside walks.

Details

Blythburgh is on the A12, south of Southwold. The church and the river are on the left side of the A12 with the rest of the village on the right. There is car parking for visitors to the church next to it. Be very careful when exploring near the A12; there are speed restrictions, but it is a dangerously busy road. Parts of the footpath on the riverside have recently been breached by the river. The footpath is very narrow in places and unpassable in muddy conditions.

49 Southwold

Often known as Chelsea-on-Sea because of the town's well-heeled second homeowners, Southwold is a pleasing coastal resort. During school holidays and in the summer, the town appears to reach its capacity with people and cars, but it still has the feel of an old-fashioned, quaint, British bucket-and-spade seaside holiday destination.

At first glance its appeal appears to be just for those with young families who play on the sand, relax in the beach huts and have fun on the recently rebuilt pier; however, it also has a draw to those with an interest in Britain's naval history.

The Battle of Solebay took place near Southwold in 1672 between the Dutch and British fleets in the conflict that became known as the Third Anglo-Dutch War. The battle is visibly commemorated in the town with the six cannons on Gun Hill – much climbed upon by visiting young holidaymakers.

The current cannons were given to the town in 1746 – many years after the battle – and have been in their prominent position overlooking the sea ever since. However, the cannons and their position caused problems during the First World

War when the German fleet mistook them as evidence that the east coast had been fortified. The cannons were prudently removed from their prime coastal position during the Second World War.

Southwold is also famed for its food, coffee shops and Adnams, the brewery and distillery. Adnams and Southwold are intrinsically interlinked, with the brewery founded in Southwold in the 1870s. Their headquarters are still in the centre of town and the company is a huge part of the town's prosperity and success.

Above: The pastel colours of Southwold's beach huts.

Below: Whether your interests are crabbing, boats, walking or simply spending time in the excellent pub, there are plenty of ways to spend time in Southwold's harbour. Lining the harbour are wooden huts containing fishmongers and restaurants. A good twenty-minute walk from the town's centre through the sand dunes, a visit to the harbour is obligatory.

Walking along the seafront is always an agreeable experience in Southwold, whatever the season or weather. The walk from pier, past the beach huts and through the sand dunes to the town's harbour is particularly appealing. For me, the reward at the end of this walk is always some seafood from one of the huts, then on for a drink in the old-fashioned, but always busy, Harbour Inn.

Details
Southwold is to the north-east of the A12 at Blythburgh. Follow either the A1095 or the B1126 into the town centre. There is a public car park next to the pier (on the seafront) and roadside parking all through the town.

50 Covehithe

With coastal erosion an ever-increasing problem for the tiny hamlet of Covehithe, this is one place to visit in Suffolk before the brutal sea claims it. Once known as North Hales, today Covehithe has a population of around twenty people. In former times, however, it was a popular and prosperous village with its own harbour, pub and magnificent church. Records show that the village had seventy-two taxpayers in 1327, but by 1674 only thirty-six households, demonstrating that its heyday was the medieval period.

During the English Civil Wars (1642–51) Puritans swept through the village and, under the orders of William Dowsing, destroyed the church's religious pictures and inscriptions. In 1672, two churchwardens were given permission to dismantle the old church (by which time, by all accounts, was already in ruins), and to build a new one. The church's original tower was kept but the new church – consisting of a small thatched building against the old tower – was largely built from reused materials from the old one. Fortunately for us, a great deal of the old medieval church remains today. These ruins are riveting to me, not just to photograph but to look in awe at medieval building techniques. This was once a significant church, built to show off its patron's wealth and social status with extravagant black stonework built into the external masonry of the building.

Despite Covehithe being a tiny hamlet, it is a place of two halves: the first being the remains of the old St Nicholas' Church and the second being the village's beach. Covehithe Beach is one of Suffolk's hidden secrets. There is no access to it by car but instead, there is a well-signposted footpath. The beach is a good twenty minutes' walk (or quicker on a bicycle), but the rewards at the end are extensive. Stay away from the fast-eroding cliffs and keep to the footpath to find the fine-looking sandy beach. A short walk north along the beach takes you

to Benacre National Nature Reserve with its coastal lagoons, reedbeds, woods, heath and beach. Alternatively, walk south towards Southwold – its pier and lighthouse can be seen in the distance from Covehithe Beach.

Details

Covehithe is on the Suffolk coast, halfway between Kessingland (to the north) and Southwold (to the south). There are a small number of parking spaces near the church in Covehithe. When walking to the beach, keep to the signposted footpaths and check the tide timetables as some parts are only accessible at mid- to low tide.

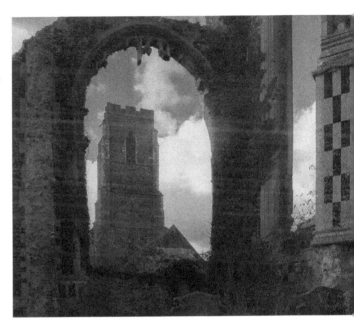

Right: A view of the church's tower from within the remains of the medieval church. The tower is from the original church but was made redundant in the 1970s. The wealth and prosperity of the medieval church can be determined from the elaborate and precise black stone incorporated into the building's external fabric.

Below: The beach is one of Suffolk's hidden secrets. On a blustery October afternoon, the beach was all but deserted – except for a few hardy walkers, cyclists and stone throwers.

Bibliography

Maps
Complete Footpath Guide: Suffolk Coast (Finial Press).
Dymond, D. P., *Hodskinson's Map of Suffolk in 1783* (Dereham, 2003).

Books
Bettley, J., and Pevsner, N., *The Buildings of England: Suffolk East* (London, 2015).
Bettley, J., and Pevsner, N., *The Buildings of England: Suffolk West* (London, 2015).
Blackwood, G., *Tudor and Stuart Suffolk* (Lancaster, 2001).
Defoe, D., *Through the Whole Island of Great Britain* (London, 1724).
Defoe, D. (ed. by Richardson, S.), *A Tour Thro' Great Britain* (London, 1742).
Dyer, A., *Decline and Growth in English Towns 1400–1640* (Economic History Society, 1991).
Evans, G. E., *The Days That We Have Seen* (London, 1975).
Evans, G. E., *The Pattern Under the Plough* (London, 1966).
Parker, R., *Men of Dunwich: The Story of a Vanished Town* (New York, 1978).
Sandon, E., *Suffolk Houses: A Study of Domestic Architecture* (Woodbridge, 1977).
Storey, N. R., *The Little Book of Suffolk* (Stroud, 2013).
Trist, P. J. O., *A Survey of the Agriculture of Suffolk* (London, 1971).

Reports
Millward, J., *An Assessment of the East Coast Martello Towers* (English Heritage, 2007).

Websites
British Library, *The British Newspaper Archive*, https://www.britishnewspaperarchive.co.uk.
Goodge, M., *British Listed Buildings*, http://www.britishlistedbuildings.co.uk.
Page, W. (ed.), *A History of the County of Suffolk: Volume 2* (London, 1975), http://www.british-history.ac.uk/vch/suff/vol2.
Palmer, J. J. N., and Slater, G., *Open Domesday*, http://www.domesdaymap.co.uk.
University of Plymouth, *Vision of Britain*, http://www.visionofbritain.org.uk.
Suffolk County Council Archaeological Service, *Suffolk Heritage Explorer*, https://heritage.suffolk.gov.uk.